IMAGES
*of Rail*

# SACRAMENTO'S
# STREETCARS

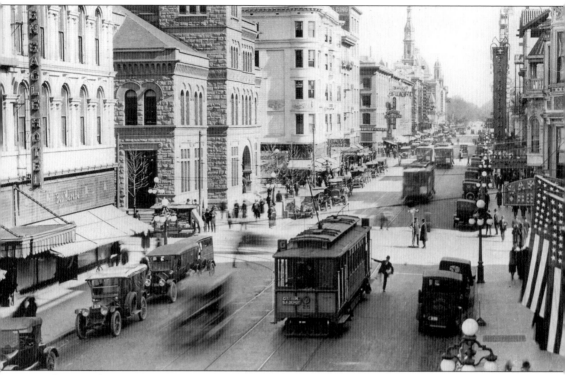

**ON THE COVER:** On K Street, *c.* 1920, five streetcars are visible in the four blocks between the Golden Eagle Hotel at Seventh Street and the Cathedral of the Blessed Sacrament on Eleventh Street. Between these points are the old post office building, Hale's Department Store, the Orpheum Theatre, Fairyland, the Clunie Hotel, the Hippodrome vaudeville theater, and the Ochsner office building. Automobiles are already present on the streets, but they travel in the shadow of the streetcars.

IMAGES
*of Rail*

# SACRAMENTO'S
# STREETCARS

William Burg

ARCADIA
PUBLISHING

Published by Arcadia Publishing
Charleston SC, Chicago IL, Portsmouth NH, San Francisco CA

Printed in the United States of America

Library of Congress Catalog Card Number: 2006923325

For all general information contact Arcadia Publishing at:
Telephone 843-853-2070
Fax 843-853-0044
E-mail sales@arcadiapublishing.com
For customer service and orders:
Toll-Free 1-888-313-2665

Visit us on the Internet at www.arcadiapublishing.com

# CONTENTS

# ACKNOWLEDGMENTS

This book is the result of my work with the Western Railway Museum's collection of Sacramento photographs. The Western Railway Museum, located at Rio Vista Junction, is a public museum operated by the Bay Area Electric Railroad Association (BAERA.) Except for those indicated otherwise, all of the photographs in this book are from that collection. In appreciation for access to this collection, all author's royalties from this book will be contributed to the Western Railway Museum, specifically for the restoration of the Sacramento streetcars in their collection. My thanks to the archive staff and volunteers, especially archivist Bart Nadeau, Mike Dreiling, and Harry Aitken, who helped provide many answers to my constant deluge of questions, and to BAERA member Grant Hess, whose photographs and knowledge of Oak Park history added much to this book.

Thanks also to Bob Blymyer for his technical assistance, peer review, and information about early streetcar lines and the buses of the post-streetcar era. Bob has been a BAERA member for over 30 years. Thanks also to Tom Tolley and the staff of the Sacramento Room at the Central Sacramento Library, Kyle Wyatt of the California State Railroad Museum, and the staff of the Sacramento Archives and Museum Collections Center (SAMCC).

Thanks to my editor at Arcadia, John Poultney, for encouraging me to start this book and as the deadline approached, urging me to finish it.

Thanks to my wife, Vivian, for her support, encouragement, and understanding.

Thanks to Birdie Boyles, Jack Davis, and Al Balshor, who shared their memories of the streetcars and life, work, and play in Sacramento.

Finally, thanks to the rail fan photographers of the Bay Area Electric Railroad Association who photographed Sacramento's streetcars. These photographers include (but are not limited to) Roy Covert, Peter Khyn, F. T. Hill, Addison Laflin, E. L. Estacaille, and Vernon Sappers. Without their enthusiasm for streetcars and their copious photographs, this book would be impossible.

# INTRODUCTION

Sacramento's streetcars were a way for people to get where they wanted to go, whether the people in question were the passengers on the cars or the companies who owned them. Seldom was the streetcar an end in itself. For riders, the cars were a way to get to work, to school, to shopping, or to recreation. For those who built them, streetcars were rarely a profitable investment, but they helped make other ventures profitable. In both cases, once the streetcars had outlived their purpose, they were abandoned. Decades later, Sacramentans would rediscover the streetcar and all the places it could take them.

Sacramento evolved along its streetcar lines. Once the Central Pacific Railroad was completed in 1869, with Sacramento as its western terminus, traffic to Sacramento was increased to levels not seen since the gold rush. The downtown passenger depot became the nexus of the city's transportation network. The downtown district along J and K Streets became the center of a network of streetcar tracks belonging to several different companies. Nearby downtown neighborhoods were also well served by the streetcar network. Feeder lines out to the suburbs spread like a spider's web from downtown, usually ending at some form of park or recreational attraction. These destinations would bring residents from the central city to the edges of town to play, swim, and perhaps consider buying a home in the suburbs close to the car line.

Expenses for a streetcar line were high. In addition to the costs of maintaining cars and track, early horse-drawn streetcar companies had to feed and stable sufficient horses for their runs, and the working life of a horse in streetcar service was very short, only three to five years. Streetcar companies were responsible for sprinkling Sacramento's dirt streets to keep down dust and later for paving the street around their tracks. Once electricity was introduced, streetcar company owners no longer had to pay for horses and hay, but electrical equipment and infrastructure had its own set of expenses. The high-voltage wires needed to power streetcars added, quite literally, overhead.

Investors hoping to build new housing developments on open tracts of land could attract customers with the promise of convenient access to a car line, and often streetcar service came before the construction and occupation of Sacramento's early suburbs. Land speculators purchased farmland on the perimeter of Sacramento's city limits and then built rails from downtown to their new tracts. Prospective home buyers were given rides to the new neighborhood on the brand new streetcar lines. These neighborhoods were often little more than lines on plat maps, a streetcar line down a road promised to be the future main street, and a stand offering free beer to potential customers.

Operating a streetcar that runs to an open field of for-sale lots was not a profitable enterprise, but it was an effective advertising tool. Potential home buyers could be certain that the promise of streetcar service to their future home was not an empty one. When a developer did not own a streetcar company, they could often pay a railroad to provide this service for the new suburb. Sometimes the process worked in reverse, and representatives of the streetcar company went into the real-estate business. When the new neighborhood was populated with new homeowners, they

7

would provide natural customers for the streetcar line. Interurban railroad companies, hoping to secure right-of-ways through cities, offered local streetcar service as a way to gain permission to ship more profitable freight and long-distance passengers through town. Sometimes the freight business outlived the passengers and the streetcars.

Parks and other recreational destinations were often used by streetcar companies to attract customers and revenue, both for their streetcars and for their suburban land tracts. McClatchy Park and McKinley Park both began as private amusement parks owned by the streetcar line. Baseball fields, public baths and pools, and historic attractions were all considerations for a streetcar companies' route planning, even when they were not owned by the streetcar company.

Once the land was sold and the homes built, however, the streetcar was not always profitable. If population density was not sufficient once a tract was developed, streetcars were not profitable to run. There were other routes to profit via the streetcar, however. The method that stood the greatest test of time was electric power. Inexpensive hydroelectric power, via long-distance transmission from Folsom, provided Sacramento with an inexpensive and plentiful supply of power. When entrepreneur Albert Gallatin built his powerhouse, he knew that a streetcar system would provide an excellent regular customer and promptly bought and consolidated the Sacramento system. This combination allowed the Sacramento streetcars to operate through the Great Depression, when many other cities' streetcar companies went out of business. Electric power and electric streetcars operated together under the banner of Pacific Gas & Electric until 1943, when the streetcar system was sold to Pacific City Lines, a subsidiary of a national company, National Car Lines (NCL).

NCL, like other streetcar operators, had another profit-making motive. Many streetcar lines, stretched thin by the Great Depression, were losing money, and reinvestment in new equipment was generally not possible. By buying streetcar lines and then taking the cars out of service, they could buy buses, tires, and gasoline sold by their major shareholders—General Motors, Goodyear Rubber, and Standard Oil. Buses required no overhead power lines, were not responsible for street maintenance, and routes could be changed with little notice to reach new suburbs when the streetcar companies were unable to invest the money needed for expanded routes and service. The streetcars received one last burst of use during the gas rationing of the Second World War, but after 1945, the end was near.

Even before National City Lines cut the power to Sacramento's streetcars in January 1947, it seemed that the day of the streetcar had passed. PG&E shut down several streetcar lines and replaced others with buses as early as the 1930s. Buses were considered more modern than streetcars, could change their routes without expensive engineering projects, and the roads were paid for by public tax funds rather than by the streetcar company. Most importantly, Sacramentans were buying private automobiles and moving out of the central city, abandoning the streetcars and the neighborhoods they had served. The streetcar system, closely tied to the central city, was no longer useful to a population that lived and worked in suburbs.

One group of people did appreciate the streetcars for their own sake: rail fans. Many rail fans are simply interested in steam or diesel railroads, but a special breed is attracted to streetcars and interurban electric railroads.

Native Sacramentans Birdie Boyles, Jack Davis, and Al Balshor all grew up in Sacramento during the era of the streetcars. All three shared their memories of Sacramento in the age of streetcars, where they went, and what they did. Other than their origin in Sacramento, they had very different lives—Birdie worked for the State of California in the Department of Education, Jack worked for Southern Pacific Railroad as a field engineer, and Al Balshor owns a florist business in Land Park. All three shared their stories of drugstore ice cream counters, K Street on New Year's Eve, the Solons at Edmonds Field, the diverse ethnic neighborhoods, and of course the clanging, rattling streetcars that got them wherever they wanted to go in town for a nickel. Their memories and words are scattered throughout the text wherever appropriate.

# One

# HORSE CARS AND ELECTRIC WIRES

Sacramento's first experiment with public streetcars, a horse-drawn line from Third and R Streets to Second and K Streets, was built in 1858 but lasted only until a flood in 1861 destroyed it. Through the 1860s, Sacramento's first public conveyances were horse-drawn omnibuses, which pulled passengers on Sacramento's dirt streets. The completion of the Central Pacific Railroad in 1869 spurred the need for a public streetcar system, since Sacramento was originally the Central Pacific's western terminus.

Sacramento's City Street Railway, using horse-drawn cars, carried its first customers on August 20, 1870, for a fare of 5¢. Riders traveled from the Central Pacific station at Front and K Streets to the State Agricultural Society's California State Fairgrounds at Twentieth and G Streets. By July 1871, the line had extended south to the City Cemetery on Tenth and Y Streets and east to Thirty-first and H Streets, site of the streetcar company's privately owned East Park. The railway company had a horse barn at Tenth and K Streets, which was later moved to Twentieth and K Street.

In 1887, several horse-drawn streetcars of the Central Street Railway, a competing line based on Twenty-eighth Street, were converted to battery-powered electric drive, but these experiments were short-lived. Electric power would not prove practical for public transit until power could be transmitted directly to the cars by an overhead wire. In 1890, Sacramento's first electric trolley line was completed, powered by coal-fired steam generators. The day of the horse-drawn streetcar ended. The Central Street Railway Company became the Central Electric Railway Company.

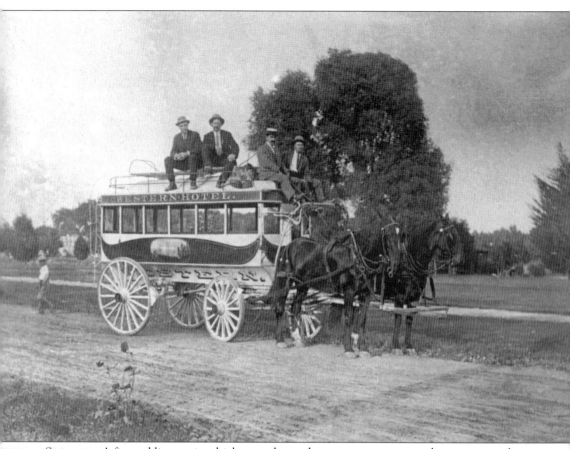

Sacramento's first public transit vehicles were horse-drawn passenger wagons known as omnibuses. This photograph, taken around 1860, shows the omnibus of the Western Hotel, located at Second and K Streets. Many hotels offered omnibus service as a way to attract travelers from the Central Pacific station on Front Street to the front door of their hotel. For service across town, Sacramentans rode the City Omnibus Line, owned principally by Thomas Berkey. This omnibus company operated between the Central Pacific station at Front and K Street and Sutter's Fort at Twenty-eighth and K Streets. After the destruction of the original street railway system in 1861, several applications were made to the city to construct street railways during the 1860s but none were completed until 1870. (Bob Blymyer collection.)

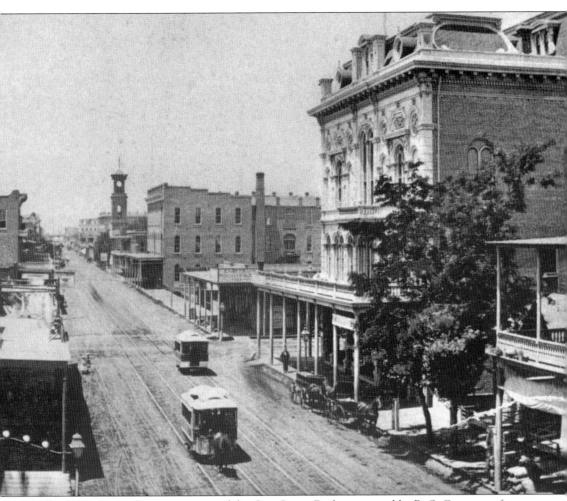

In the 1870s, horse-drawn streetcars of the City Street Railway, owned by R. S. Carey, ran from the Central Pacific station to K Street, through Sacramento to the state fairgrounds at Twentieth and G Streets, and ended at East Park on Thirty-first Street. Carey was also the president of the State Agricultural Society, host of the state fair, between 1873 and 1877. The fairgrounds, originally known as Union Park, were purchased in 1862 by the State Agricultural Society and were located between E and H Streets and Twentieth and Twenty-second Streets in the neighborhood now known as Boulevard Park. The original set of eight horse cars were ordered from the Kimball Manufacturing Company, based in San Francisco. Kimball produced horse-drawn streetcars, cable cars, omnibuses, and even steam railroad cars for the Central Pacific and Virginian & Truckee railroads. Two cars arrived in time for the first day of service on August 20, 1870. The other six went into regular service shortly afterward. Service to East Park began on July 24, 1871. (Author's collection.)

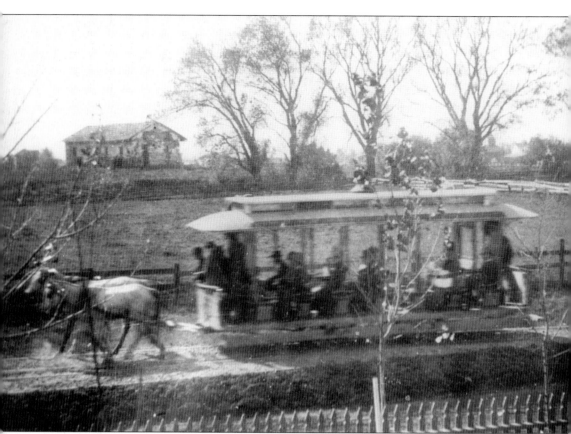

This photograph shows a horse-drawn car traveling past Sutter's Fort on the Central Street Railway. This building was all that remained of the original fort, before its restoration and reconstruction began in 1891. Although it was started as a streetcar line, the Central Street Railway was the first company in Sacramento to use electricity to power its streetcars. The company was owned by Sacramentans Edwin K. Alsip and Leonidas Lee Lewis. Alsip had previously operated a real estate, insurance, and notary public business with his partner Albion Chase Sweetser at 47 Fourth Street. L. L. Lewis owned a plumbing and tinware business at 502 J Street in addition to his part in the street railway business. (Bob Blymyer collection.)

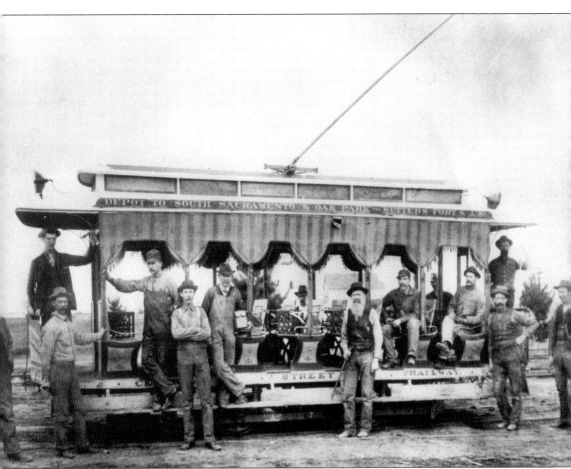

This early Central Street Railway streetcar was probably converted from a horse-drawn car. Electric power had many advantages over horse-drawn streetcars, including higher speeds, greater reliability, and easier street cleaning. Experiments with battery-powered streetcars in 1888 proved short-lived because the batteries were exhausted after only a few runs, and horse cars were returned to service for three more years. In 1891, the Central Street Railway bought out the horse car lines owned by R. S. Carey. This gave the Central Street Railway two separate lines downtown—their original line on J Street and the City Street Railway's line on K Street. The company was soon renamed the Central Electric Railway Company. (Bob Blymyer collection.)

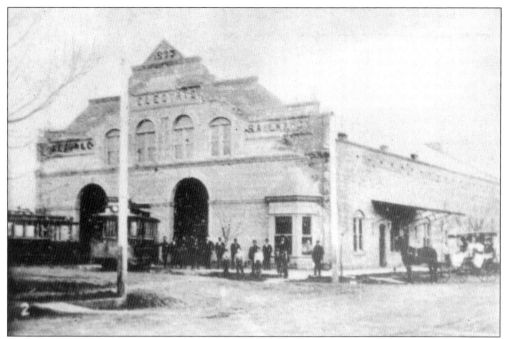

The Central Electric Railway built this carbarn on Twenty-eighth Street between M and N Streets. This barn was later expanded to hold more cars with an extensive shop and repair facility. During the brief experiments with battery-powered streetcars, this carbarn was also the point where streetcars went to recharge. (Bob Blymyer collection.)

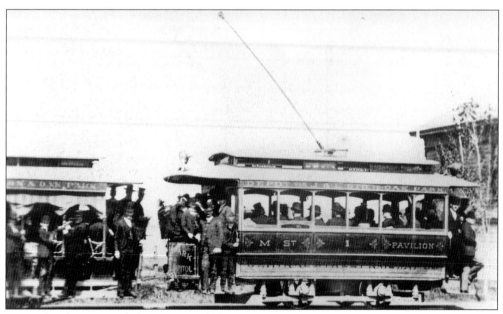

Two Central Street Railway cars, crowded with passengers, are about to depart for the M Street line. This line ran from the Central Pacific passenger depot downtown to J Street, then began a series of zigzags down Eleventh, L Street, Fifteenth, M Street, and Twenty-Eighth Street before leaving the city limits and heading to Oak Park.

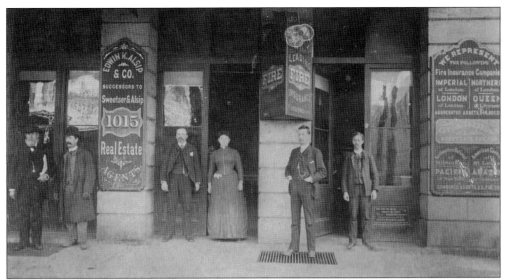

The real estate office of Edwin K. Alsip, vice president and general manager of the Central Street Railway, was located at 1015 K Street. This building was also Central Street Railway's headquarters. Alsip purchased the 380 acres of land that became Oak Park from William Doyle. Pictured in the photograph, from left to right, are Sol Runyon, L. Rivett, Edwin Alsip, Bel Dockstide, R. H. Hawley, and Neeley Stanely. (Grant Hess collection.)

The eastern terminus of the Central Street Railway was in Oak Park. Like the City Street Railway's East Park, Oak Park provided a recreational destination for streetcar riders and a neighborhood park for those who bought land from Alsip's real estate company in the Oak Park neighborhood. (Grant Hess collection.)

Albert Gallatin built his original Sacramento home in 1877 at 1526 H Street. At the time, he was employed as manager of Huntington and Hopkins Hardware. In the 1860s, the owners of Huntington and Hopkins, Collis P. Huntington and Mark Hopkins, were busy constructing the Central Pacific Railroad and needed an experienced manager. Gallatin came west to join in the gold rush but soon discovered that selling hardware paid better than panning for gold. As manager of the hardware store that sold equipment to Central Pacific, Gallatin prospered. When Gallatin moved to San Francisco with Huntington and Hopkins' headquarters in 1887, he sold the house to Lincoln Steffens. Steffens in turn sold the house to the State of California for use as the governor's mansion. The mansion has not been inhabited by a California governor since Ronald Reagan in 1967. (Author's collection.)

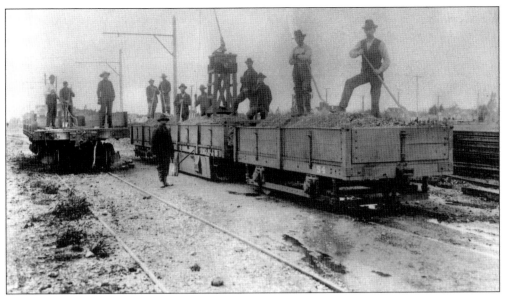

In 1892, H. P. Livermore and Albert Gallatin applied for their own franchise to construct an electric railway, the Sacramento Electric Power and Light Company, which brought two major changes to Sacramento's streetcar system. They consolidated the streetcar systems in town into a single line and, in 1895, electric power from Folsom was transmitted to Gallatin's powerhouse on Sixth and H Streets, 22 miles away.

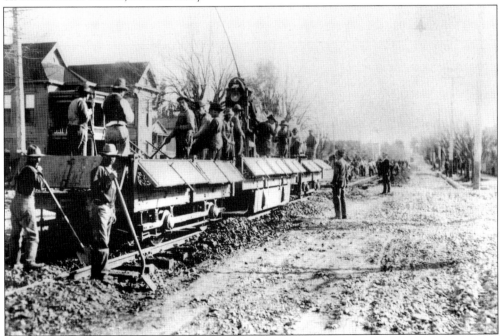

These construction photographs were part of a collection presented to Gallatin by his employees in 1906, the year he retired. This construction shot shows crews laying ballast on J Street near Seventeenth for a new electric streetcar line. Once the rails were in place, the streetcar company was responsible for maintaining the right-of-way in the street, which included sprinkling the streets with water in summer to control dust.

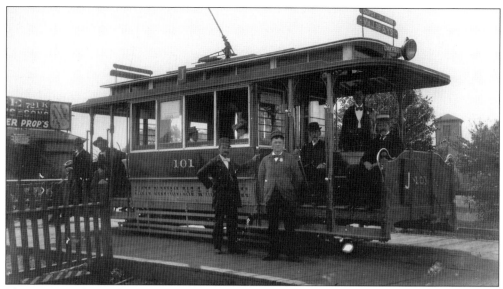

This streetcar, lettered for the Sacramento Electric, Gas, and Railway Company, is parked at its Oak Park terminus. After Gallatin's power company purchased the other Sacramento streetcar companies, they were consolidated as SEG&R in 1895. By that year, there were seven separate car lines operated in Sacramento, mostly between G and P Streets. Two lines ended at East Park, four at Oak Park, and one at the city cemetery.

The downtown end of the line for all seven streetcar lines was here at the Southern Pacific passenger depot. The railroad station was the point where most people arrived and departed from Sacramento, and thousands of Sacramentans worked at the Southern Pacific shops on the far side of the depot. This depot, built in 1879, replaced the original passenger depot at Front and K Streets.

# Two

# THE CARS
# OF SACRAMENTO

Many of the original streetcars owned by SEG&R were converted from horse cars, like the battery-powered cars of 1887, while others were built in the company shops on Twenty-eighth Street. These early cars were improved several times over the years to reflect changes in technology and expand capacity. An important improvement was conversion from a single truck with four wheels on two axles in a rigid frame under the car to a double truck with one set of two-axle trucks on each end of the car, which resulted in a larger car and a smoother ride.

Electric streetcars were a revolutionary improvement over their horse-drawn predecessors. Horse-drawn cars were slow, and horses were difficult and expensive to feed and maintain. Cable cars were used in many American cities, pulling cars via an underground cable in a channel between the tracks, but these systems were mechanically complex due to the elaborate network of cable and reels required for such a system. Electric battery cars were tried but judged impractical due to the great weight of the batteries and their short service life, requiring frequent recharging. The trolley pole, with a metal wheel in direct contact with the wire, provided an excellent solution for safe transmission of power. Combined with powerful electric motors, trolley pole streetcars were faster than horse cars or cable cars, with simpler maintenance and lower operating costs. By 1900, they were nearly universal.

Electric streetcar service began in Sacramento in 1890, using coal-fired steam boilers to generate electric power, but the era of electricity was inaugurated on July 13, 1895, when the Folsom Powerhouse first transmitted power to Substation A on Sixth and H Streets. This was followed by a grand electric carnival on September 8 and 9, 1895, that featured floats and displays pulled by electric motors and powered by the overhead wire. In 1906, the Sacramento Electric, Gas, and Railway Company became part of the larger regional company—Pacific Gas & Electric, or PG&E. Based in San Francisco, their local offices were located at the Substation A powerhouse.

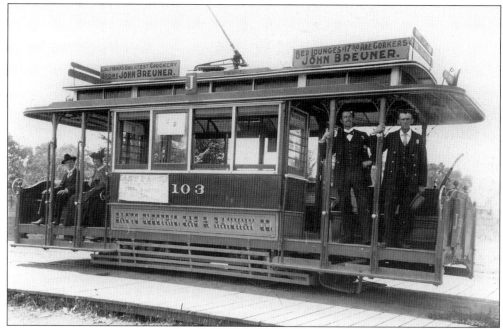

SEG&R Car No. 103 is parked at the end of the line, preparing to depart for Oak Park via J Street and Twenty-eighth Street. It is a single-truck car, probably a conversion from an early horse-drawn car. Cars like this drew power from a single overhead trolley pole, which could be reversed by the motorman. Reversing the pole allowed the car to change direction. (Bob Blymyer collection.)

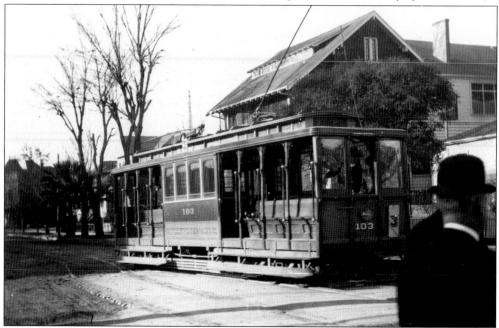

This is also a photograph of Car No. 103, rebuilt as a double-truck car. In addition to their larger capacity, double-truck cars had a smoother ride due to their more complex suspension. There are also two trolley poles, one at either end of the car. To reverse direction, the motorman uses a rope to pull down the trolley pole after raising the pole on the opposite side.

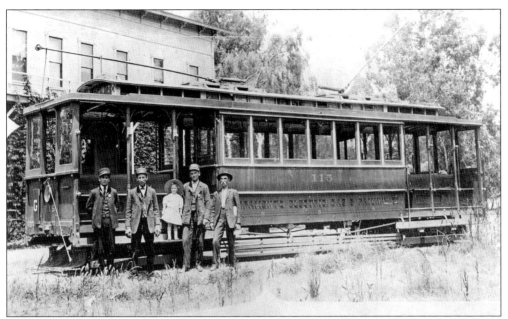

This two-truck streetcar is known as a "California car" due to its open ends and enclosed center section, as well the comfort of passengers in warm Sacramento weather. The trucks on many of the SEG&R cars were used freight car trucks purchased from the Southern Pacific Railroad. The truck assemblies were turned upside down and electric motors and gearing systems installed by SEG&R crews at the company shops on Twenty-eighth Street.

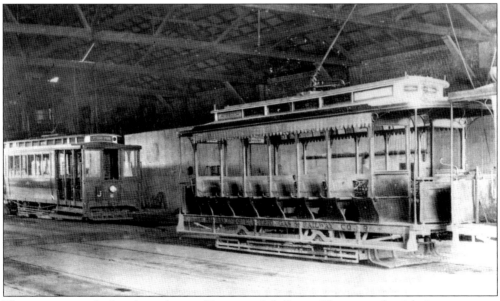

These cars are parked in the carbarn at Twenty-eighth Street. The car on the right is an open car, with bench seats running the width of the car, accessible from either side. The car on the left is a California car. The motorman is exposed to the weather in either type of car, but passengers have some protection from the weather in an enclosed car.

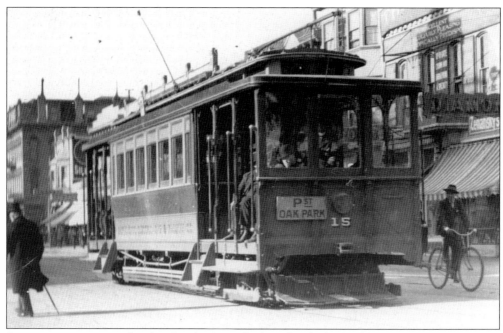

Streetcars were equipped with safety fenders at both ends. The basket-like arrangement under the end of the car is designed to drop down and scoop up a person or animal that has fallen on the tracks in front of the car. While being caught in the fender of a moving streetcar was an uncomfortable experience, it was less dangerous than being struck by the metal wheels of the car.

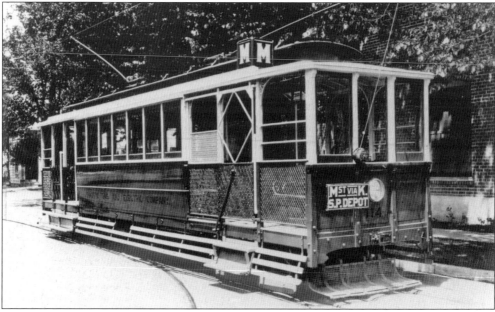

This California car has been enclosed with pneumatic gates for one-man operation. Earlier cars were manned by a motorman, who operated the car, and a conductor, who collected fares. Enclosed cars were operated by a single motorman, who could accept fares from riders when stopped, then close the doors of the car to prevent riders from hopping on without paying the fare. This change lowered costs for the streetcar company.

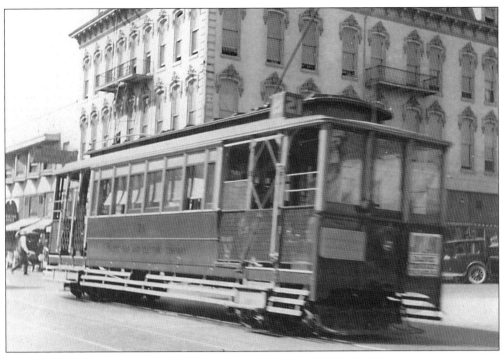

These early cars were equipped with rope brakes. This braking system consisted of a sturdy hemp rope that was looped loosely around a drum on the axle. When the motorman pulled the brake lever, tension was applied to the rope, which tightened around the drum and stopped the car. This system worked, as long as the rope did not break. Rope brakes were also called "twister brakes" by motormen.

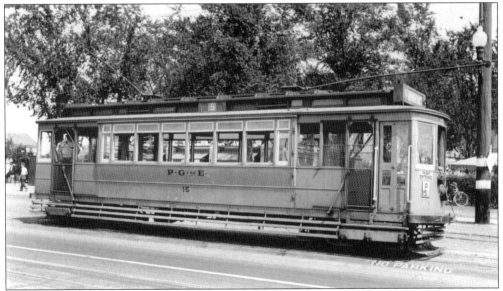

As time went on, the California cars were fully enclosed. Windows could still be opened on hot days, but a fully enclosed car prevented rain from entering through the open spaces on a California car. The ends were also rebuilt for a smoother, rounded appearance and were equipped with an anticlimber. The cars were equipped with destination signs above each end of the car.

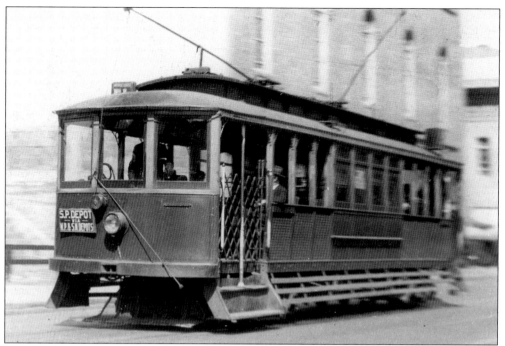

Car No. 37 was part of an order of six cars purchased from the American Car Company in 1914. These cars were originally built as open California cars. They were equipped with air brakes, which were far more reliable than the earlier rope brakes. Gates were installed for one-man operation.

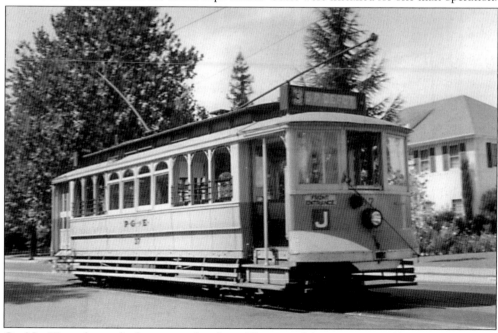

Car No. 37 was later rebuilt as an enclosed car. The cars of this series were all in operation until the end of streetcar service in 1947, thanks to the successive upgrades and improvements to the cars. One of these cars, Car No. 35, has been restored and occasionally runs on downtown Sacramento's light-rail tracks.

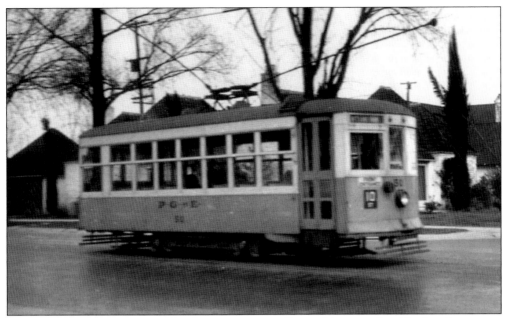

Single-truck Birney streetcars like this one were smaller and less comfortable than larger cars but were inexpensive to purchase and operate. These were the first metal-framed cars purchased by PG&E. Known as "Birney Safety Cars," they included features like a deadman switch, which automatically stopped the car if the motorman became incapacitated; air brakes; and a sturdy metal frame. Wood was still used extensively in the body of the car.

The first Birney cars were these smaller seven-window cars, purchased in 1918. They were light, inexpensive, and incorporated Birney's many safety features. However, they were unpopular with customers due to their cramped size and slow speeds. All of these smaller seven-window Birney cars were taken out of service and scrapped by 1933. The eight-window cars were operated until 1944. (Bob Blymyer collection.)

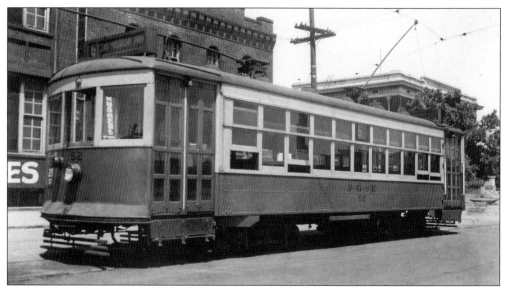

This two-truck Birney safety car was purchased by PG&E in 1924, part of an order of six. Like the single-truck Birneys, they featured a metal frame and exterior, air brakes, and safety anticlimbers. Unlike the single-truck designs, they had a smooth ride and were more spacious and comfortable. These cars were used until the end of streetcar service.

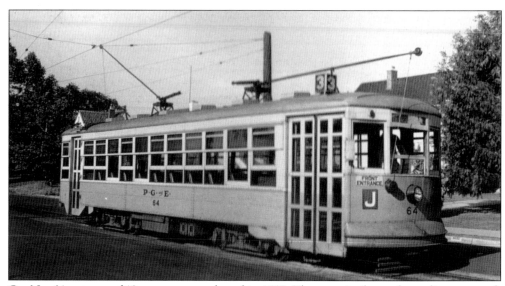

Car No. 64 was one of 12 streetcars purchased in 1929. They are similar to the earlier two-truck Birney cars, but their destination signs are mounted on the front of the car rather than on the top, giving them a cleaner, more streamlined look. These cars were known as the "Christmas cars." Delivered near the end of 1929, they originally carried signs reading, "PG&E's Christmas present to Sacramento."

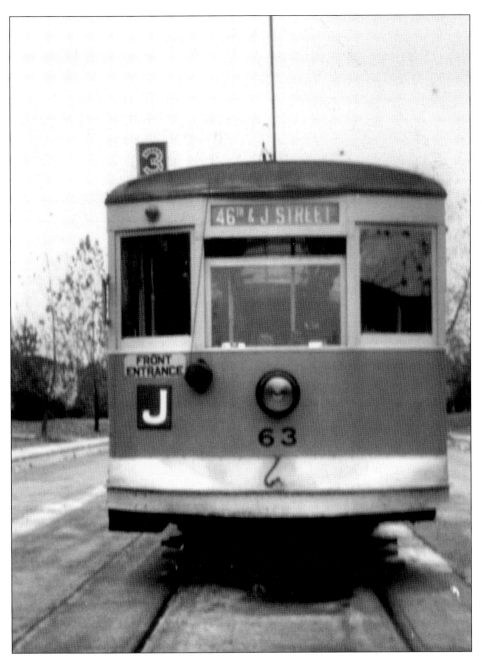

In this close-up of one of the Christmas cars, many details are visible. The round object to the left of the headlight is a reel for the rope that is used to raise and lower the trolley pole. Directly under the trolley pole is a hook intended to hold down the trolley pole when the pole was not in use. The apparatus under the car is part of the safety fender: if something strikes the wooden lattice under the car, the fender drops down to catch it. The end of the car is equipped with an anticlimber. This heavy metal lip was designed to interlock with anticlimbers on other streetcars in a collision. This kept cars from "telescoping," or one car literally entering the other car with fatal consequences, in the event of a high-speed accident. Many streetcars built without anticlimbers had them installed in later upgrades.

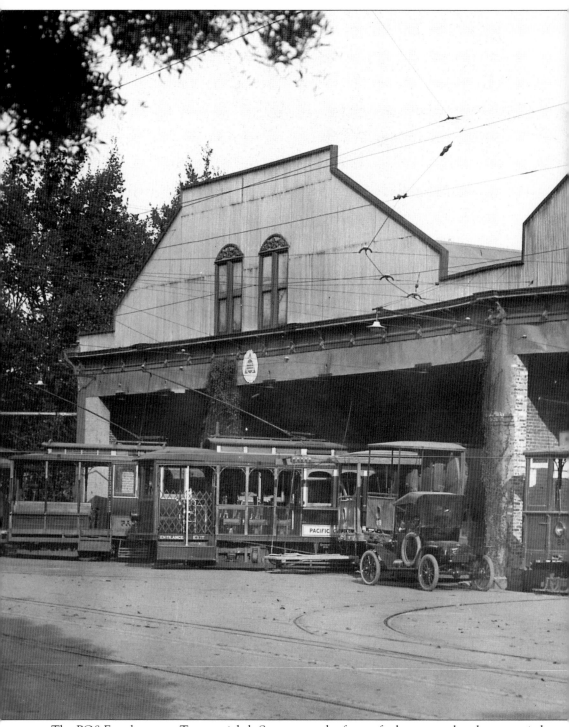

The PG&E carbarns on Twenty-eighth Street were the front of a large complex that occupied half a city block. Several different types of cars can be seen, including some flat-front PG&E cars and some of the newer American Car Company cars. Behind the automobile in the middle of the photograph are work motors 99 and 100. Car No. 99 has a large water tank for its job as a

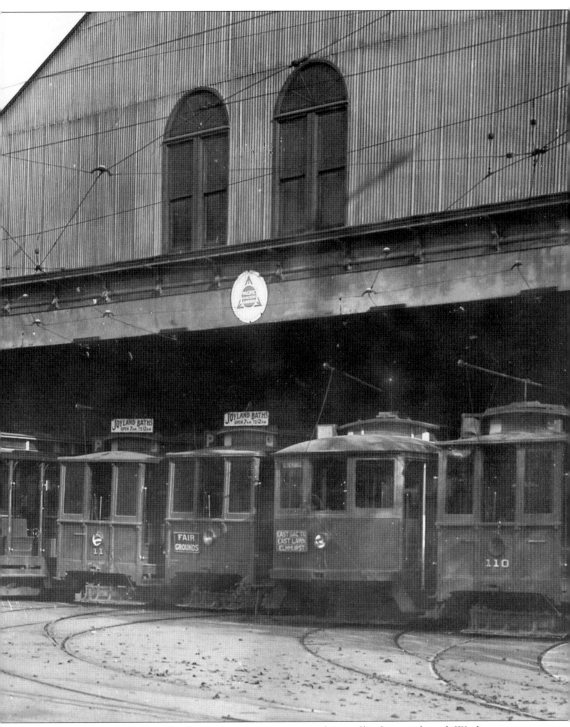

street sprinkler, while Car No. 100 has an open center and a small cab at each end. Work motors were commonly used by streetcar companies for maintenance, repair, and carrying supplies from point to point on the line.

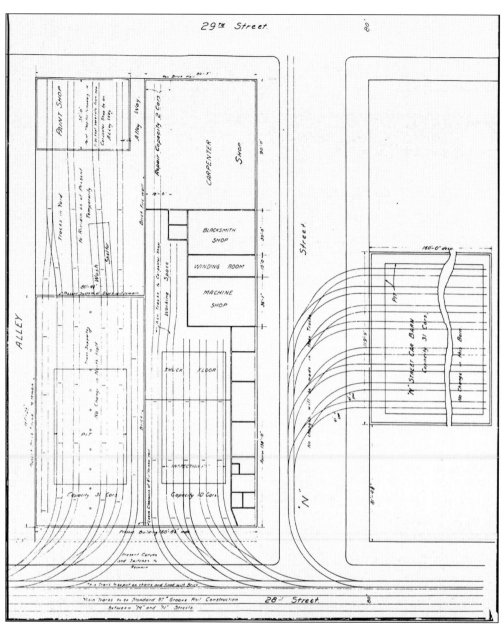

This map shows the arrangement of the PG&E car shops and storage barn. The shops occupied half a city block, with extensive facilities for construction, painting, rebuilding, and maintenance of streetcars. Many of the original Sacramento streetcars were built here, and this was the site of the various upgrades and rebuilding of cars. Open pit floors allowed crews direct access to the underside of cars for motor maintenance. Carpentry shops repaired wooden portions of the cars, the blacksmith and machine shop could repair metal components. A separate building in back of the lot housed the paint shop, which repainted cars. Sacramento's cars had a reputation for immaculate paint jobs, so this building saw frequent use. The smaller carbarn across N Street was strictly for car storage. That structure still stands today, occupied by Sacramento Regional Transit offices. Cars were sometimes parked on the storage track on N Street, but generally cars were stored inside the carbarn when not in service.

The PG&E corporation yard was located at Twenty-eighth and R Streets. Maintenance equipment and supplies were stored here. This yard was also used to store cars that were no longer used in revenue service. In this 1939 photograph by Roy Covert, two of the early Sacramento rope-brake streetcars, retired from service, sit awaiting their fate.

Surplus streetcars were sold after having their electrical equipment removed. This car still has its trucks, but its trolley poles, headlights, and motors are gone. Cars like this were turned into diners, storage sheds, chicken coops, or even homes. This photograph clearly shows the trucks used on these cars, originally surplus Southern Pacific freight car trucks.

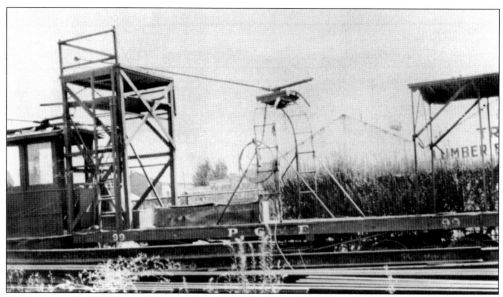

Work motor No. 99 began life as a street sprinkler, but after Sacramento's streets were paved, it found other uses. In this photograph, it looks like a flatcar with some wooden structures attached to its body, but its trolley pole and traction motors allow it to operate under its own power. Over time, it saw many uses as a line car, rail-bonding car, and general-purpose work car. (Bob Blymyer collection.)

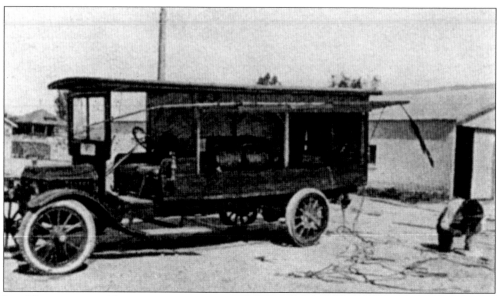

In addition to its rail-borne maintenance cars, PG&E used line trucks like this one for general service and repair of poles and overhead line. Trucks were useful for line repairs because, unlike a work motor, they could move out of the way for passing streetcars while out working on the line. (Bob Blymyer collection.)

# *Three*

# DOWNTOWN
## J AND K STREETS

Sacramento's early streetcar lines were centered near the waterfront, where most of the population lived. As J and K Streets grew into Sacramento's commercial business district, the streetcar lines followed those streets eastward. Sacramento's inhabitants expanded eastward too, building houses farther away from the busy waterfront.

Downtown maintained a varied character and served many roles in Sacramento. The shopping district along J and K Streets featured department stores, theaters, banks, hotels, and many retail businesses. Along Front Street, the city wharf was lined with warehouses, canneries, lumberyards, and factories. Along the northern edge of downtown, the massive Southern Pacific shops employed thousands, and the Southern Pacific passenger depot was the city's gateway to the rest of the world. Two electric interurban railroads, the Oakland, Antioch & Eastern and the Northern Electric, carried passengers from the Bay Area and the northern Sacramento Valley to their downtown terminals. Streetcars were needed to carry workers to and from work, shoppers to and from stores, and travelers to and from train stations.

J Street had a more professional character, with many private office buildings, government buildings, and banks. K Street was a retail center, featuring a wide variety of hotels, theaters, restaurants, and large department stores. Tenth Street featured more government offices, including city hall, the state capitol, and the two state office buildings between Ninth and Tenth Streets.

Downtown Sacramento was considered the only place to go for shopping, at department stores like Weinstock and Lubin, Kress, or Hale's. Downtown theaters and ballrooms provided entertainment for all ages. Sacramento residents Al Balshor and Birdie Boyles both recalled taking the city streetcar to the New Year's Eve festivities on K Street in the 1930s, when streets were blocked to automobile and streetcar traffic between Fifth and Twelfth Streets. People promenaded through the closed streets, engaging in various forms of gaiety and revelry. Well after midnight, Sacramentans took the streetcar home.

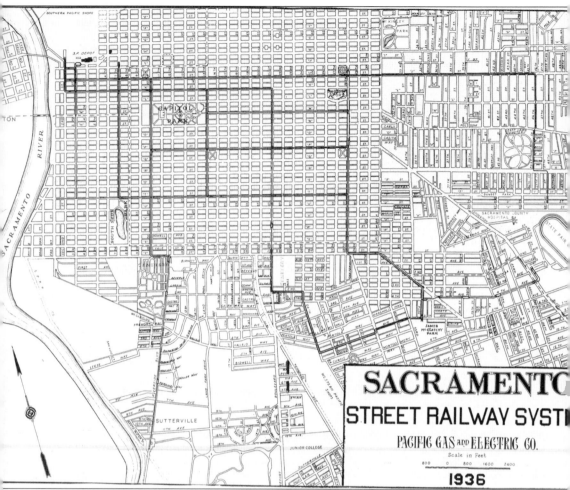

This 1936 map shows the PG&E streetcar lines through Sacramento. In the upper left are the Southern Pacific shops and passenger station, both major destinations for workers and travelers. Most streetcar lines started at this point and ran along J or K Streets on their way into the residential neighborhoods. Downtown and the central city residential neighborhoods were very well covered, but lines running into the suburbs were sparse—a single line runs into East Sacramento and Elmhurst, on the upper right, and a single line runs south to Land Park, in the lower left. The lines running to the California State Fairgrounds, lower right, meander through the neighborhoods of Curtis Park and Oak Park. By this date, the G Street line to McKinley Park had already been taken out of service, and the Third Street line had been replaced by a bus.

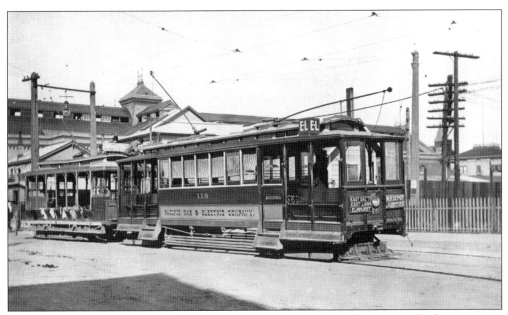

The Southern Pacific passenger depot and shops area were a major destination for the streetcars, carrying passengers to and from the station and the shops' employees to and from work. The locomotive works and shops were the largest employer in Sacramento, and the Southern Pacific depot was the largest passenger station in the region. Car No. 119 and an unidentified single-truck car wait for passengers at this end of the line.

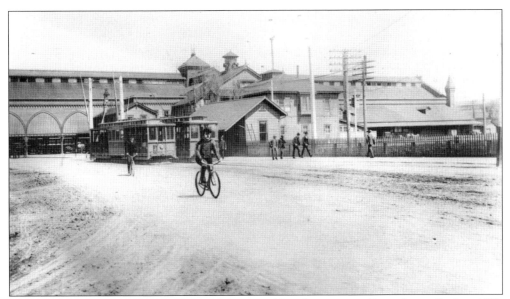

This large wooden depot replaced the earlier Central Pacific station on Front Street. Built in 1879, the depot was a large gallery with multiple passenger tracks running through it. The Sacramento Locomotive Works complex is just behind this building. Because of the density of traffic to this point, the depot was a logical place for the downtown end of the streetcar lines.

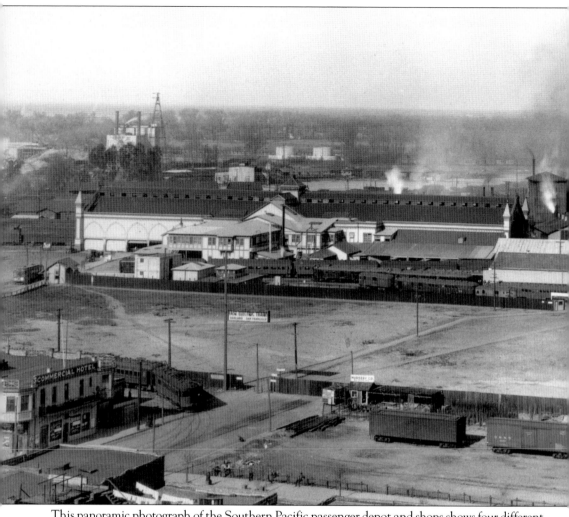

This panoramic photograph of the Southern Pacific passenger depot and shops shows four different forms of rail travel. The large gallery building on the left is the Southern Pacific passenger station. On the lower left is the passenger station of the Oakland, Antioch & Eastern, an electric interurban railroad that ran between Sacramento and Oakland. In between these two buildings is Southern

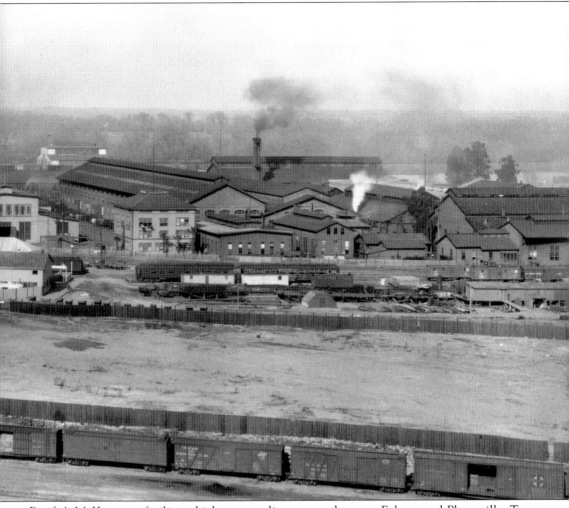

Pacific's McKeen car facility, which ran gasoline-powered cars to Folsom and Placerville. To the far left is a Sacramento streetcar, blocked from entry to the station by the tracks of the new Southern Pacific station about to be built on the empty lot on the lower right.

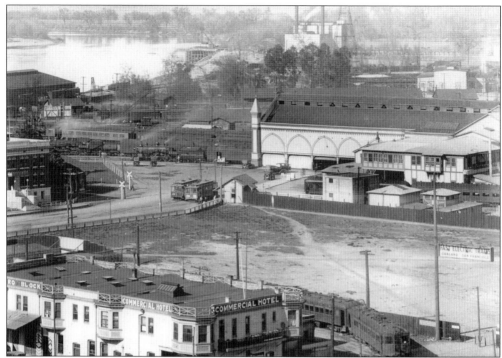

This aerial view shows the electric OA&E interurban train just behind the Commercial Hotel, and behind it, two Sacramento streetcars wait for passengers at the Southern Pacific station. The OA&E later united with the Northern Electric to become the Sacramento Northern Railroad. This modest terminal at Third and I Streets was convenient for transfer to local streetcars or the Southern Pacific station.

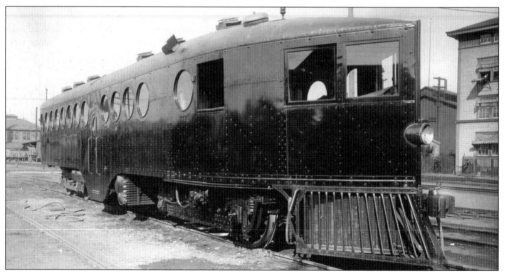

The McKeen gas motor cars were used by Southern Pacific to compete with electric interurban railroads. They were known as "Skunks" by the passengers due to their strong gasoline smell. McKeen cars were used from 1907 until 1928 for daily round-trip service to Folsom and Placerville. An important function of the McKeen car routes was carrying students from outlying communities to Sacramento High School.

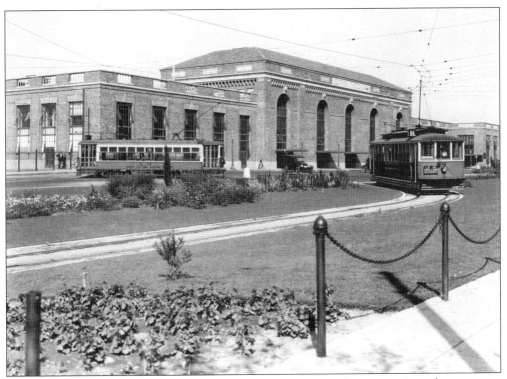

Built in 1925, the Southern Pacific passenger depot still stands today serving Amtrak passengers. It replaced the old wooden gallery station with a more modern and durable structure. When the streetcar line was originally constructed to this station, cars turned around on a loop surrounded by this pleasant green parkway and reversed direction without having to change their trolley poles.

The parkway was later removed to make way for a ramp to allow cars to cross the I Street Bridge to West Sacramento. After the loop was removed, streetcars parked in these bays outside the Southern Pacific depot. The depot still served as the end of the line for many streetcar routes.

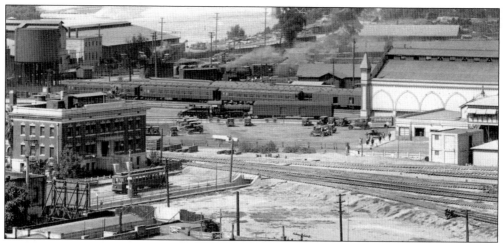

When the new passenger depot was built, new tracks were laid that blocked pedestrian access to the Southern Pacific station and shops, so a short subway was built at Second and H Streets to allow pedestrian traffic. In this photograph, taken while the new station was under construction and the old one still in use, the subway is in the center, just to the right of the streetcar.

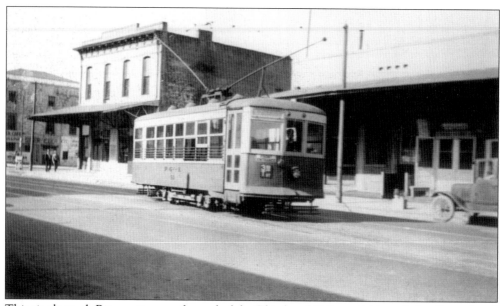

This single-truck Birney sits near the end of the Third and T line, which ended at Second and H Streets. This car ran along Third Street, providing commuter service between the canneries, railroad buildings, and warehouses near the waterfront, and the neighborhoods where the workers at these industries lived, near Southside Park.

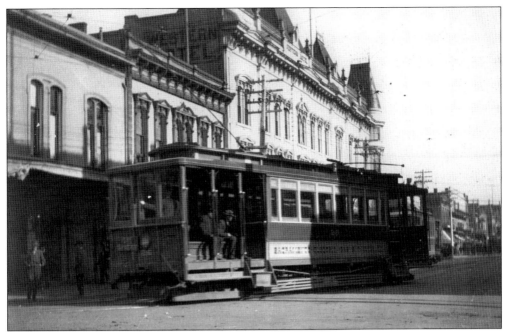

The neighborhoods near the train station were lined with many of Sacramento's grandest hotels, providing convenient respite for newly arrived travelers. The streetcars provided quick service to the hotels along J and K Streets and were faster than the old horse-drawn omnibuses. This car is turning from Third Street onto K Street, with the Western Hotel in the background.

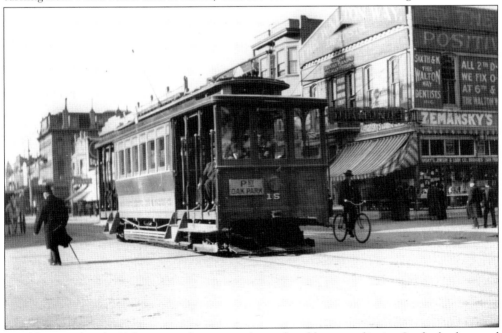

In addition to hotels, K Street was Sacramento's retail and business district. In the background is the Metropolitan Hotel, and the streetcar is just passing Zemansky's Jewelry and Loan and the dentistry offices of Dr. Walton at the corner of Sixth and K Street. A wide variety of small local stores and services were interspersed between the larger businesses on K Street.

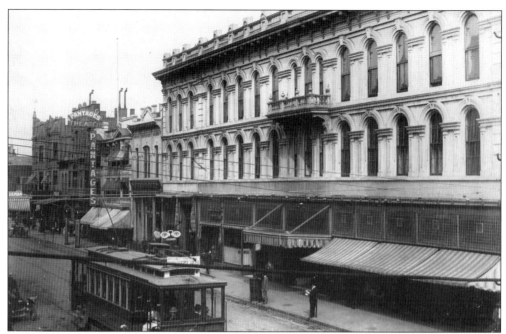

A block farther down K Street, approaching Seventh Street, the streetcar passed the Pantages Vaudeville Theater and the Golden Eagle Hotel. Across the street is John Breuner's furniture showroom. Advertisements for Breuner's products were often posted on Sacramento streetcars. None of the buildings in this scene have survived to the present day.

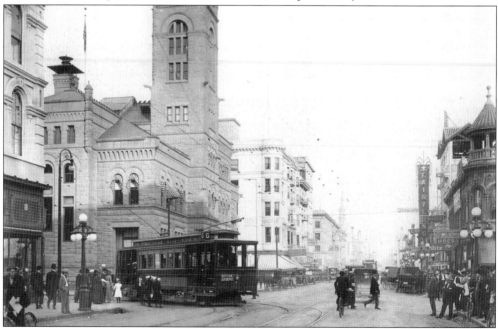

In this McCurry photograph, a G Street line car pulls onto K Street from Seventh Street. The post office, visible in the background, was constructed in 1894. Directly behind the post office is the Ochsner Office Building. The Ochsner Building still stands, but the post office is now an open park area, used as an outdoor ice-skating rink in winter.

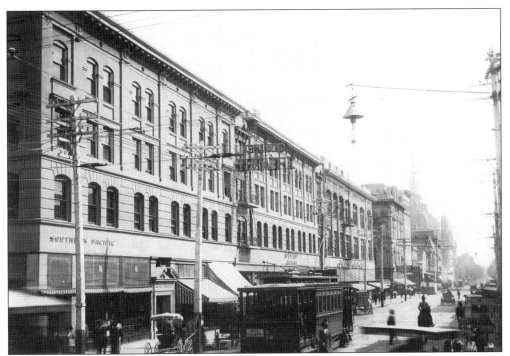

K Street at Eighth was the home of Hotel Clunie and Hale's Department Store. A large number of jewelry stores were also located on this block. The Cathedral of the Blessed Sacrament can be seen in the distance, obscured by fog. Until the coming of skyscrapers, the cathedral, built in 1889, was the tallest building in the city.

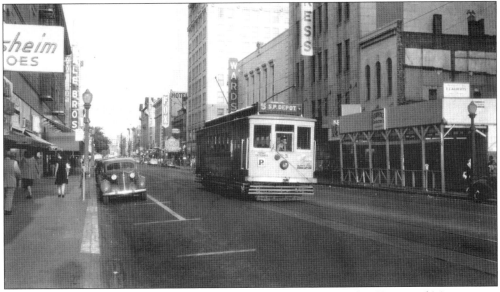

The other side of K Street was occupied by Silver's Jewelry, Kay Jewelry, Kress, and Montgomery Ward. K Street was well known for its many department stores. Weinstock and Lubin was originally located on the next block, before they relocated to newer quarters at Twelfth Street. According to Birdie Boyles, locations east of Tenth Street, like the Weinstock's location, were generally called "uptown."

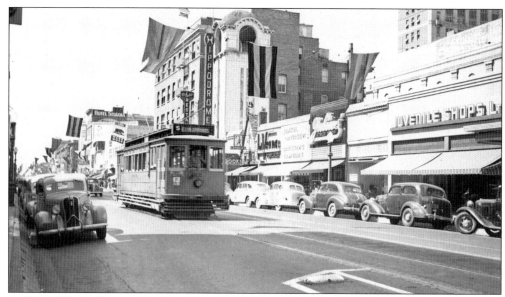

At K and Tenth Streets, Car No. 22 passes the Hippodrome Theater and Levinson's Books. K Street was lined with many theaters and other entertainment venues, including the Fox Senator Theater and Trianon Ballroom. Jack Davis remembered the day that the movie was interrupted at the Senator Theater, on December 7, 1941, to announce the bombing of Pearl Harbor.

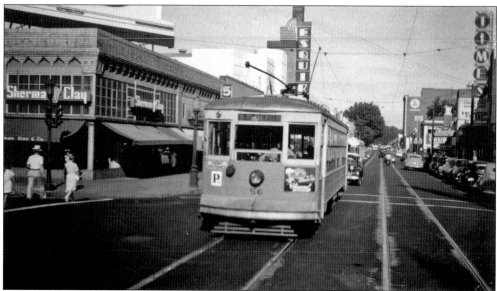

At Twelfth and K Streets, Car No. 56 passes the Esquire Theater. Beyond the theater was the Willis and Martin Pharmacy, where Al Balshor worked delivering medicines. He used a three-wheeled motorcycle, rather than the streetcar, for his deliveries. Al had to quit, because much of his $50-a-month salary went to pay his frequent traffic tickets for failing to stop at stop signs while making deliveries.

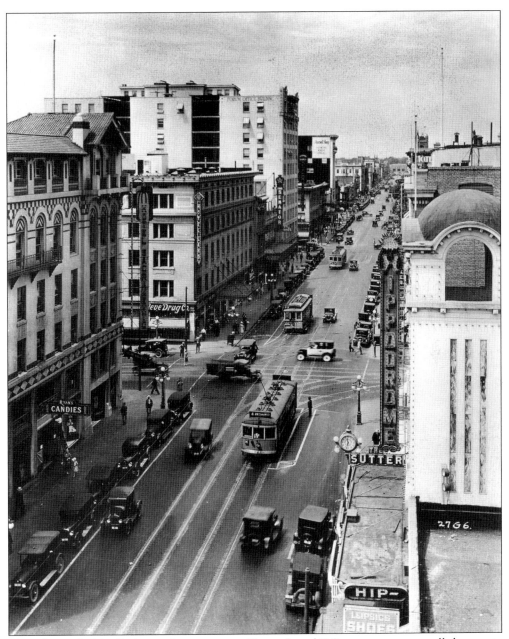

From the roof of the Parkview Apartments at Eleventh and K Street, one can see all the way to the freight station on Front Street. No less than three streetcars are visible in this photograph, competing for space in the street with a growing number of automobiles. The Hippodrome Theater, whose sign is on the right, has a long history in Sacramento. The theater was originally built as the Empress in 1913. It became the Hippodrome in 1918. In 1921, the theater burned when a fire in a candy store next door spread to the Hippodrome's lobby. Later the Hippodrome marquee collapsed, killing two people. In 1946, the theater was renamed the Crest. The Crest is still open as a movie theater and live entertainment venue.

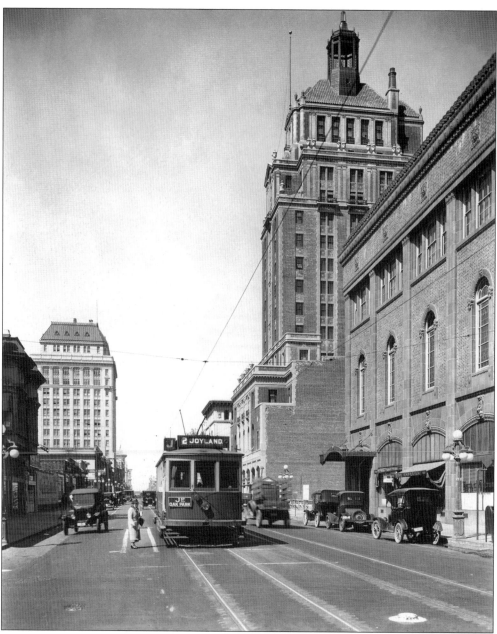

Dwarfing the streetcar, the Elks Building and the Cal-Western Insurance Building dominate this view of J Street facing west from Twelfth Street. Both of these buildings, as well as the Masonic Temple on the right, still stand today. They are two of a quartet of buildings that were known as the "Big Four," which dominated Sacramento's skyline in the early 20th century. The other two are the state capitol and the Cathedral of the Blessed Sacrament. For decades, they were the tallest buildings in town. Note the woman standing next to the streetcar in this photograph. In order to board a streetcar, passengers had to stand in the street, dangerously close to oncoming traffic. While traffic in this 1920s photograph was not particularly busy, the number of cars and the risk to streetcar passengers standing in the street increased over time.

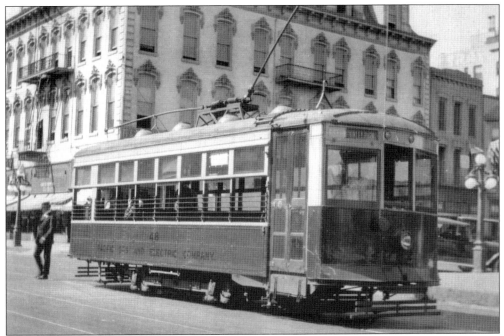

This Birney is passing the Western Hotel on K Street before it departs for G Street and McKinley Park. Birneys were ideal for the more lightly traveled lines, due to their lower operating costs. The G Street run was one of the first eliminated after the introduction of buses to PG&E's operating fleet in the 1930s.

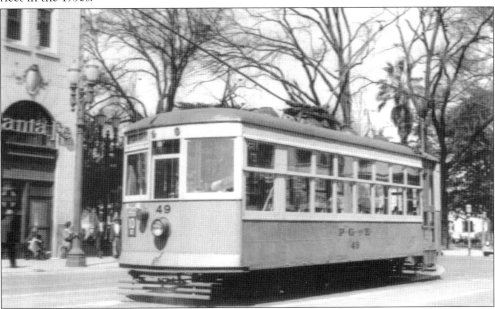

A PG&E Birney turns onto Tenth Street from J Street, near Plaza Park. The park, now known as Cesar Chavez Plaza, features a statue of Andrew Jackson Stevens, general master mechanic of the Southern Pacific shops. The statue was paid for by fellow shop employees and erected after his death in 1888. This Tenth Street car almost certainly carried many shop employees from the shops to their homes in Southside Park.

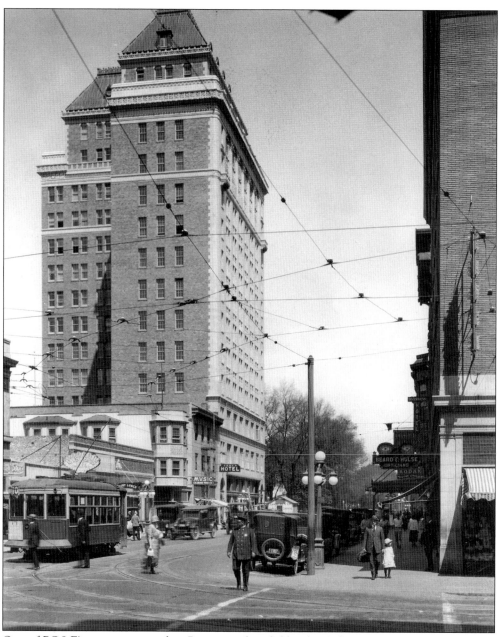

One of PG&E's tiny seven-window Birneys is dwarfed by the Cal-Western Insurance Building, built in 1925. The web of overhead wire in the photograph supports power lines above the complex double-tracked interchange between Tenth Street and K Street. These complex webs of wire, metal fittings, and support cables followed wherever the streetcars ran. According to Jack Davis, the streetcars were often beautiful, but the wires were far less appealing to the eye. The Birney car is running on the Tenth Street line, which made its way south to the city cemetery on Y Street, went past Edmonds Field, home of the Sacramento Solons baseball team, and then continued farther south into Land Park, ending at the public baths. Streetcar lines began downtown, but in order to be useful, they had to extend to the residential neighborhoods beyond the downtown core.

# Four

# MIDTOWN HOMES

After 1900, Sacramento grew to the south and the east, blocked to the west by the river and to the north by the Southern Pacific main line. The early suburban neighborhoods followed the established streetcar lines up J and K Streets and down Tenth Street. More lines were added to provide improved service to the eastern portion of town. While most of midtown was residential, there were industries along R Street following the railroad lines and commercial districts along the main streetcar lines.

At the height of streetcar service, few points in Sacramento's original city limits were more than two blocks from a streetcar line. Car lines ran past city cemeteries along the Y Street levee and Thirty-first Street, to elementary and high schools, and to the Memorial Auditorium. Retail businesses in midtown were located on streetcar lines to attract potential customers and were conveniently located for neighborhood residents.

The city's relationship with the streetcars was not always harmonious. In 1913, the city had to sue PG&E to sprinkle the streets. Dirt streets generated much dust in summer, and sprinkling them with water kept the dust down. Once the streets were paved, it was the streetcar company's responsibility to pave the street around their tracks, a responsibility that they sometimes failed to shoulder adequately. Residents demanded that new lines be built to their neighborhoods and then complained about the noise and hassle of streetcar construction. Once the lines were built, residents complained about to infrequent or to crowded cars. Despite these complaints and concerns, the streetcar was a vital part of Sacramento life, and PG&E maintained a strong reputation for clean attractive cars and timely service.

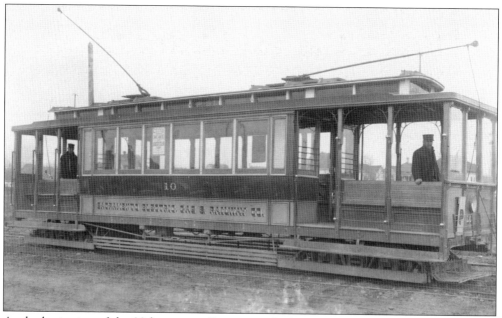

At the beginning of the 20th century, Sacramento had six streetcar routes. The G Street and H Street lines ran to East Park. The J Street, M Street, P Street, and Third Street lines took different routes but all ended at Oak Park. The Tenth Street line went south, terminating at the city cemetery on Y Street.

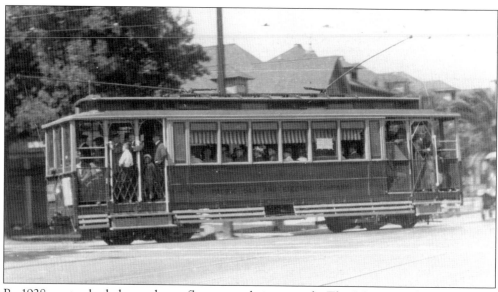

By 1928, routes had changed to reflect central city growth. The J Street and P Street lines remained, but the G and H Street lines were combined into the G–T line, which ran from McKinley Park to Seventh Street, then to T and Twenty-eighth Streets. A new line was opened down Twenty-first Street, and the Third Street line was taken out of service. A second P Street line ran to the state fair.

# Pacific Gas and Electric Co.
## CAR LINE and MOTOR COACH INFORMATION

**No. 1 Route—T Street**
Passing Court House, Chamber of Commerce, the Federal Building and Southside Park.

**No. 3 Route—East Lawn**
Passing S. P. Depot, Chamber of Commerce, Auditorium, W. P. Depot, Fort Sutter, and East Lawn Cemetery.

**No. 4 Route—M Street**
Passing S. P. Depot, the Federal Building, State Capitol Grounds, Fort Sutter, High School and James McClatchy Park.

**No. 5 Route—P Street**
Passing S. P. Depot, the Federal Building, State Capitol, Motor Vehicle Dept., High School, and the Fair Grounds.

**No. 6 Route—21st Street**
Passing the Federal Building, W. P. Depot, Christian Brothers School, St. Joseph's Cemetery and James McClatchy Park.

**No. 7 Route—10th Street**
Passing State Capitol, State Armory, Base Ball Grounds, City, Masonic and Odd Fellows Cemeteries and Wm. Land Park.

**No. 12 Route—46th Street**
Passing Chamber of Commerce, Auditorium, W. P. Depot and Fort Sutter.

**A & F Route—McKinley Park Motor Coach**
Passing the New Post Office Building, City Hall, Chamber of Commerce, Court House and McKinley Park.

**B Route—Folsom Blvd. Motor Coach**
Passing East Lawn Cemetery.

**C Route—Elmhurst Motor Coach**
Passing Fort Sutter, City and State Corporation Yards.

**D Route—Oak Park Motor Coach**
Passing New Post Office Building, City Hall, Chamber of Commerce, Court House, McKinley Park, and the High School.

**E Route—Jr. College Motor Coach**
Passing Auditorium, New Senior High School, Jr. College and Wm. Land Park.

This 1937 car line directory shows even more changes to the streetcar routes. The northern half of the G–T line was eliminated, but the T Street line was maintained as the No. 1 route. The J Street line became the No. 3 route, which extended beyond the city limits to East Sacramento and Elmhurst. The P Street line became the No. 5 route to the fairgrounds. This card also shows several bus routes. PG&E started operating buses in 1932 to fill gaps in between the existing routes, like the C route between the end of the No. 1 line and Elmhurst, or the E route to Sacramento City College. Although the No. 6 route came close, no streetcar route was convenient for the city college.

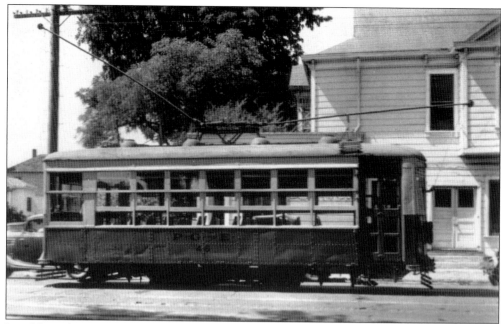

Line No. 1, the T Street route, was typically served by single-truck Birney cars. Jack Davis grew up near Line No. 1 and recalled a notorious prank involving the streetcar. By running up behind the car as it went by and grabbing the rope to the active trolley wire, one could yank the pole off the power line, stopping the car dead. This would naturally infuriate the motorman on the car!

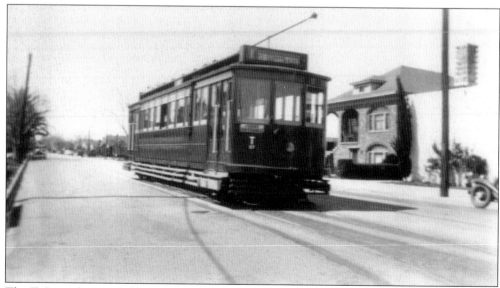

The T Street line ended here at Twenty-eighth Street. There were plans to continue the line farther down T Street to the neighborhood of Elmhurst, where it would have connected with the end of the E–L line at Forty-eighth Street, but the line was never built. While the smaller Birneys were the rule on Line No. 1, larger cars were used on baseball game days to handle the extra traffic.

Sacramento's Memorial Auditorium was completed in 1927 on the site of the Sacramento Grammar School. Sporting events, music, and high-school graduations were among the many events held here. Streetcars ran directly in front of the auditorium on J Street, allowing those attending events a convenient ride home. (Author's collection.)

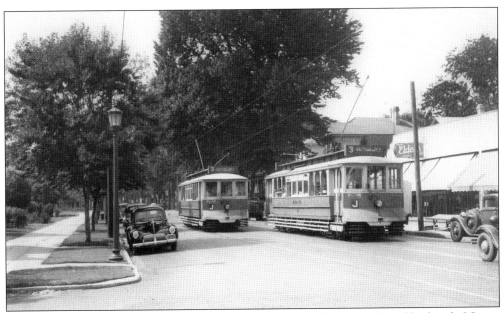

As the streetcar lines left the vicinity of downtown, they entered residential neighborhoods. J Street featured retail areas throughout most of its length in the central city, even outside of downtown. Behind these cars on Line No. 3, a scene typical of midtown Sacramento: the streetscape is completely shrouded by trees, blocking the sky with a green canopy.

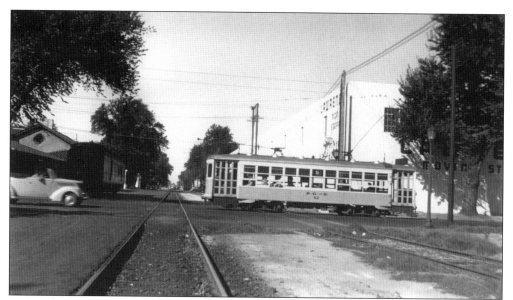

Here a PG&E streetcar on K Street crosses the Western Pacific tracks between Nineteenth and Twentieth Streets. Completed in 1909, Western Pacific was a relative latecomer to Sacramento; it ran from Oakland to Salt Lake City. Their passenger depot was an attractive Spanish Mission design but much smaller than the grand Southern Pacific depot. It still stands today as an Italian restaurant.

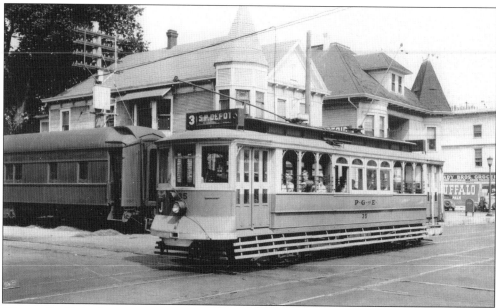

Western Pacific had a strong presence in Sacramento. In addition to their main line, they operated an industrial spur on Whitney Avenue, and their Jeffery shops, named for company president E. T. Jeffery, were located behind the Sacramento City College campus. Streetcars served both ends of the midtown passenger depot. As Car No. 35 crosses the Western Pacific tracks on J Street, a passenger coach can be seen to the left.

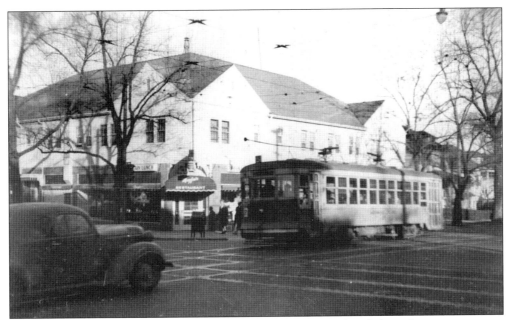

Outside of the central business district, retail establishments were found along the streetcar routes. At the corner of Twenty-first and P Streets, the Mayfair Restaurant tempts diners. While none of these retail centers approached the scale of K Street, they provided more localized neighborhood services like dry cleaners, drugstores, and food markets.

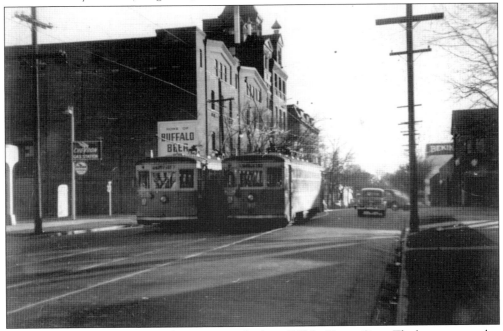

The Buffalo Brewery on Twenty-first Street was built in 1889 by Henry Grau. The brewery complex filled an entire city block. Grau merged his business with that of brewer Frank Ruhstaller in 1897. In addition to the Buffalo brand, this brewery also produced Ruhstaller and Gilt Edge brands of beer. During Prohibition, the brewery produced near beer and soft drinks but resumed beer production after the repeal of Prohibition.

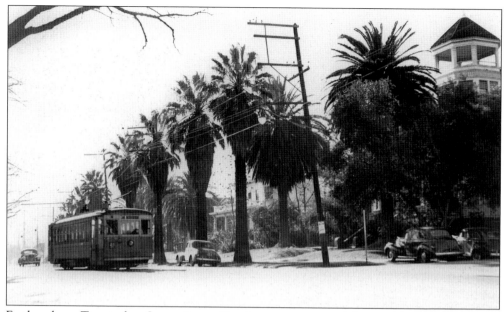

Farther down Twenty-first Street, Route No. 6 streetcars entered the neighborhood known as Poverty Ridge. Originally a spot of high ground occupied by those near the river during floods, Poverty Ridge became the home of many mansions and elegant Victorian homes, including the home of the McClatchy family, owners of the *Sacramento Bee* newspaper.

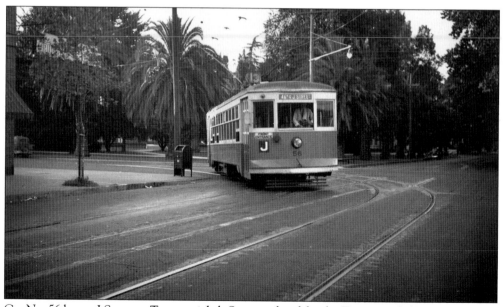

Car No. 56 leaves J Street at Twenty-eighth Street to head for the Twenty-eighth Street carbarn. Behind the streetcar is Marshall Park, one of midtown Sacramento's many city parks. Ten of these parks occupy a single city block each. While they were not as large as Southside Park or Capitol Park, they were distributed throughout the central city, accessible to all.

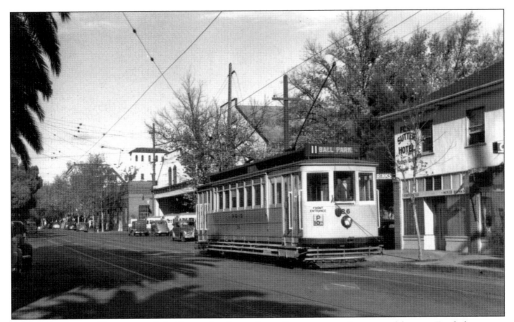

The carbarn on Twenty-eighth Street had two bays for storage of cars and buses. Both bays are visible behind the streetcar in this photograph, and several PG&E buses are visible in the barn. After the end of streetcar service, the barn was used for decades to store buses, and the site is still Sacramento Regional Transit's bus servicing facility.

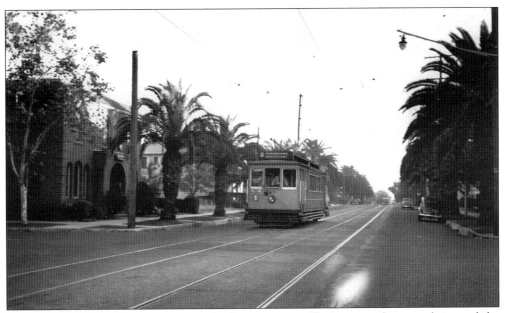

Twenty-eighth Street was a major corridor for streetcar traffic between the central city and the southeastern suburbs. A variety of retail businesses lined this street, including several markets and drugstores, such as Conrad's Pharmacy on Twenty-eighth and P Streets and Hesser's Pharmacy on Twenty-eighth and T Streets.

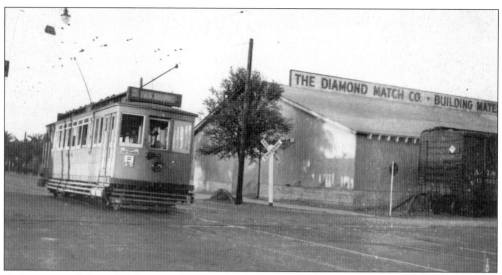

At Twenty-eighth and R Streets, the streetcar passed the Southern Pacific's industrial corridor along R Street. R Street was the home of many industries, including the Diamond Match lumber company. Today Sacramento's RT Metro light-rail vehicles run along R Street, but there is no track left on Twenty-eighth Street.

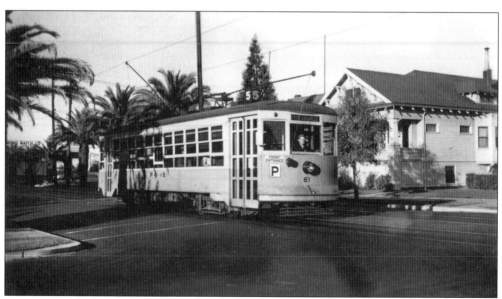

At S Street on Twenty-eighth Street, Car No. 61 enters the neighborhood near the Newton Booth School, where both Birdie Boyles and Jack Davis grew up. Jack recalled the neighborhood's strong smell in the late summer because many of the area's Italian and Slovenian inhabitants made homemade wine in the summer, and the rotting grape skins had a powerful aroma. Many who lived in this neighborhood worked at the Southern Pacific shops.

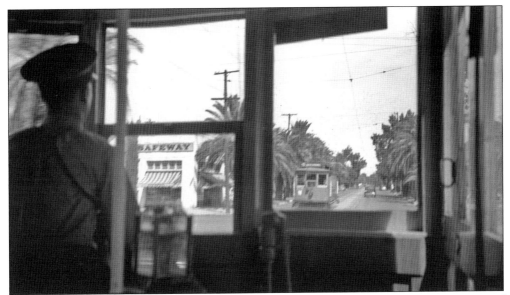

One of the businesses on Twenty-eighth Street was an early Safeway location at the corner of Twenty-eighth and T Streets. Across the street was Hesser's Pharmacy, where Jack Davis worked as a soda jerk during the Second World War. He described it as the best job ever for a 12-year-old boy, making sundaes, phosphors, and sodas for other neighborhood kids. He also delivered medicines on his bicycle.

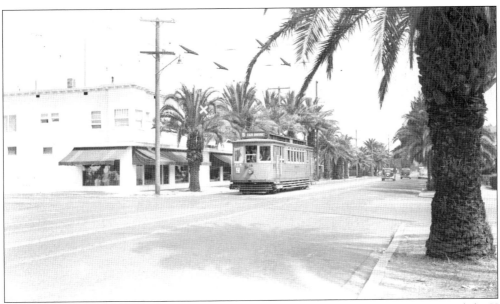

At Twenty-eighth and X Streets, just past Maggiora's Furniture, the streetcar line crossed the X Street line shared by the Sacramento Northern Railroad and the Central California Traction Company. This line carried streetcars and freight trains of both companies and crossed the PG&E tracks in several locations throughout downtown and midtown.

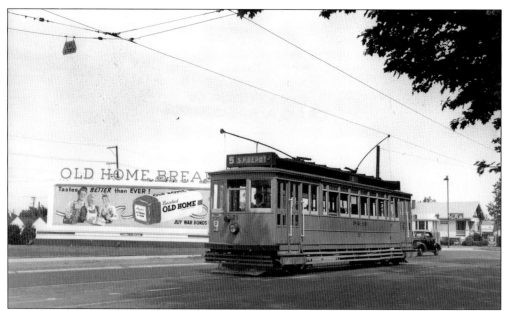

A Route No. 5 train on Twenty-eighth Street crosses Y Street, originally a levee and the southern city limit. In 1936, the street was renamed Broadway, partially due to the presence of the new Tower Theater. Similarly Thirty-first Street was renamed Alhambra Boulevard due to its Alhambra Theater. The "Buy War Bonds" message on the billboard indicates that this picture was taken during World War II.

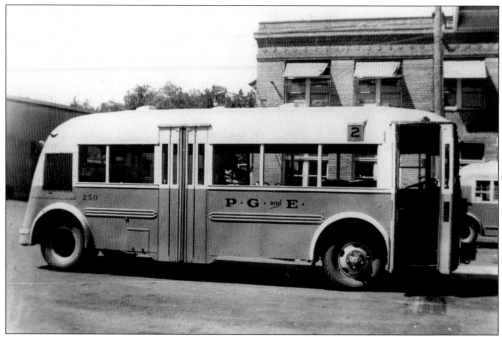

In the 1930s, PG&E purchased several Twin Coach Model 23R buses. They were gasoline-powered with manual transmissions. They were used to replace the older streetcars, provide service on less-traveled streetcar lines, and to provide service to neighborhoods where no trolley wire or tracks existed. This was much cheaper than building new streetcar lines. (Bob Blymyer collection.)

# *Five*

# STREETCAR SUBURBS

As the population of the central city grew, real estate developers bought land in outlying areas, hoping to convert them into tracts of private homes and apartments. Streetcar service to these neighborhoods was essential, since private automobiles were still relatively rare. Often developers would partner with the streetcar company in order to subsidize operating costs in neighborhoods where there were not yet enough residents to make streetcar service profitable.

Public attractions in outlying neighborhoods encouraged residents from all over the city to visit. Some of these attractions were originally owned by the streetcar company, like East Park (sold to the city in 1902 and renamed McKinley Park) or Joyland in Oak Park (renamed McClatchy Park.) Others were privately owned, like the public baths at the end of the Riverside line or the Edmonds Field baseball park. Still others were public-owned destinations like William Land Park or the California State Fairgrounds.

The streetcar suburbs, including Oak Park, East Sacramento, Curtis Park, and Land Park, allowed the city to expand following the streetcar's rails. The streetcar line made these suburbs possible, but they also represented the beginning of the end of the streetcar system. As the city expanded, the PG&E system remained concentrated in the downtown area, with radial lines reaching into the suburbs. As development spread out, the distances between convenient streetcar lines grew, and PG&E did not have the extra funds to justify building more extensive streetcar networks to adequately cover these neighborhoods. The solution to these gaps in streetcar coverage came in two parts, both of which hurt the business of streetcars—gasoline-powered buses and private automobiles.

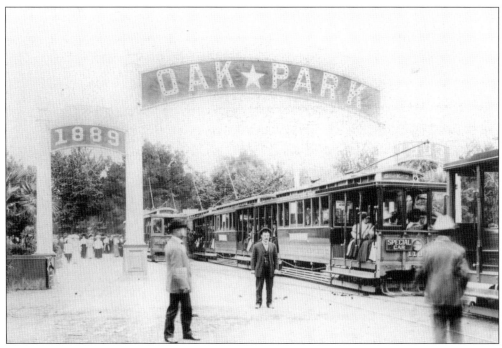

The original name of Oak Park's end-of-line amusement park was simply "Oak Park." This photograph, taken c. 1905, shows a busy day at Oak Park, with five streetcars ready at the end of the line. Oak Park featured a playground called Joyland, which opened in 1889.

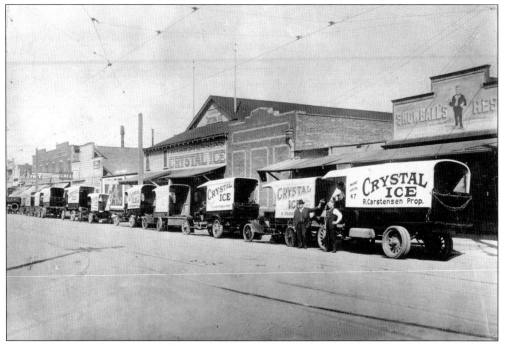

Crystal Ice trucks lined up on Thirty-fifth Street adjacent to the streetcar tracks suggest that a hot Sacramento summer is ahead. In addition to this facility, Crystal Ice had a large ice-making and refrigeration facility on R Street downtown. (Grant Hess collection.)

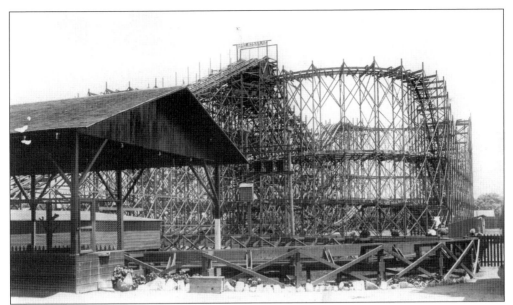

In 1913, Joyland was vastly expanded and operated by private contractors, who subleased it from PG&E. This photograph shows part of the Giant Racer, Joyland's roller coaster. Joyland burned down on June 21, 1920. The park was rebuilt, but the amusement park closed in 1927 due to poor attendance and low profits. (Grant Hess collection.)

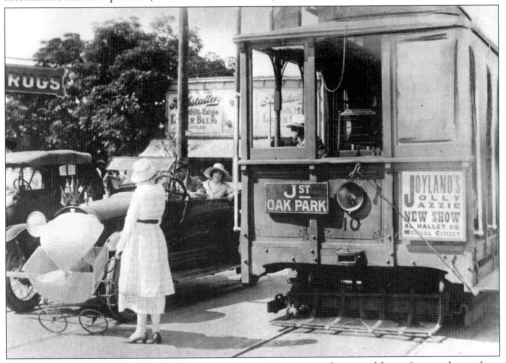

This 1918 photograph was part of a Sacramento Union article on public safety and avoiding dangerous hazards like exiting a streetcar into a busy street. The woman with the stroller is Gladys McGovern; the stroller was provided by Oak Park Furniture. In the background is Steen's Saloon. (Grant Hess collection.)

Steen's Bar, built in 1892 as the Electric Road Exchange and renamed Steen's Corner in 1908, was a fixture of Oak Park until the building was demolished in 1969. Located just around the corner from Joyland, it was a popular watering hole for fathers while the children were entertained by Joyland's various attractions. (Grant Hess collection.)

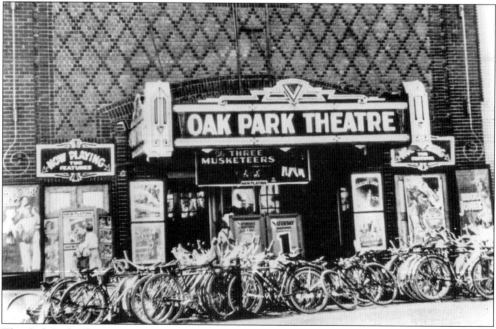

The Oak Park Theatre on Thirty-fifth Street, seen in this 1933 photograph, was a popular spot for weekend matinees. The building was constructed by Bill Lewis in 1915 and named the Victor Theater, a vaudeville and movie house. In 1933, it was sold to Cy Graves, who renamed it the Oak Park Theatre. It was later renamed the Guild Theater. (Grant Hess collection.)

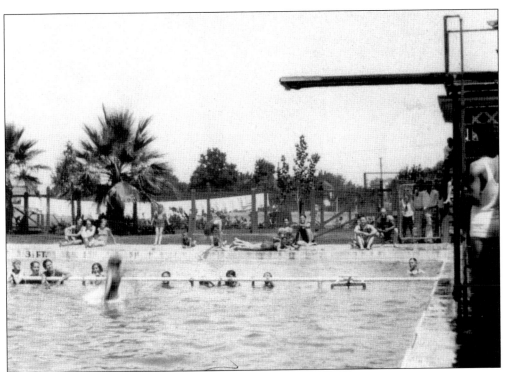

In 1927, the Joyland property was sold to the McClatchy family, who deeded the land to the city as a public park. It was renamed James McClatchy Park. This 1927 photograph shows the public pool at McClatchy Park. Birdie Boyles took swimming and lifesaving lessons at the McClatchy Park pool when she was a Campfire Girl. (Grant Hess collection.)

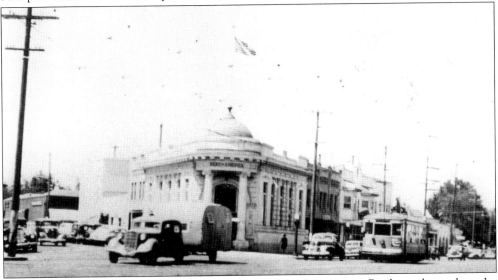

Opened on January 4, 1915, the Oak Park branch of the Sacramento Bank was located on the corner of Sacramento Boulevard and Third Avenue. The wedge-shaped building was designed by James Seadler, architect of the Stanford and Crocker mansions in San Francisco and the Llewellyn Williams home in Sacramento, now the Sacramento Youth Hostel. This bank is on the register of National Historic Places. (Grant Hess collection.)

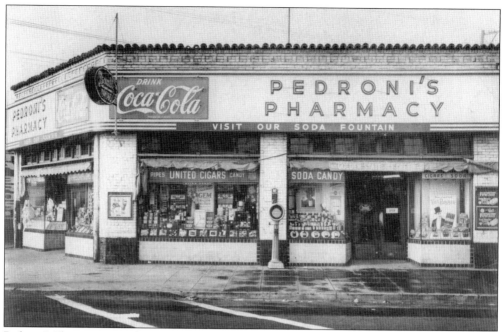

Pedroni's Pharmacy was the soda fountain of choice for Birdie Boyles and her friends when she was a student at Sacramento High School. Pedroni's was at the corner of Thirty-fourth and Sacramento Boulevard, where students got off the streetcar to attend Sacramento High School. The drugstore provided medicines but was also a soda fountain and ice cream shop and a gathering place for children and teenagers. (Grant Hess collection.)

Up the street from Pedroni's was Sacramento High School, on Thirty-fourth Street and First Avenue. Birdie Boyles often rode the streetcar to school. The original structures are gone, but Sacramento High School is still open. Unfortunately for the students, the pharmacy at Thirty-fourth and Broadway no longer serves ice cream or sodas. (Author's collection.)

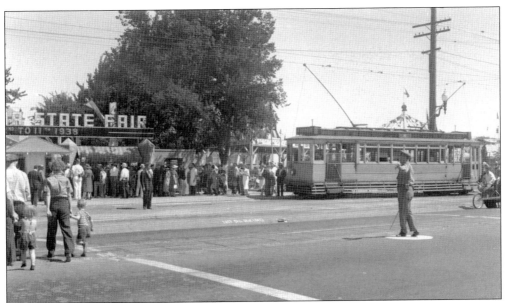

At the far end of Oak Park on Stockton Boulevard were the state fairgrounds. Line No. 5 terminated here, but during the annual California State Fair, cars were taken from other lines for more frequent service to the fairgrounds. During fair week, almost any PG&E car, including some that had otherwise been retired from service, could be found on the way to the fair. This photograph was taken by Roy Covert.

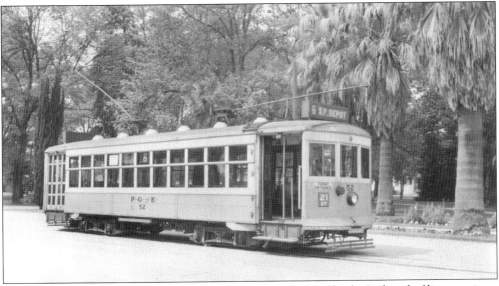

In this Peter Khyn photograph, PG&E No. 52 is seen at the McClatchy Park end-of-line terminus. Two tracks were located here so cars could park briefly in between runs, switch trolley poles, and start back out on the line on the correct track to return in the opposite direction.

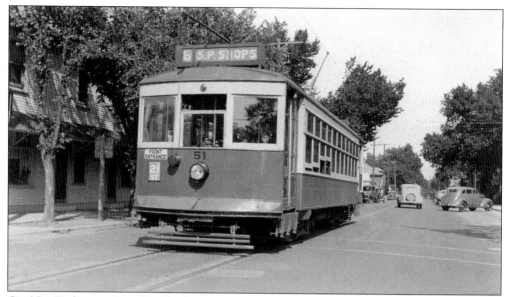

Car No. 51 departs from McClatchy Park's streetcar terminus at Fifth Avenue, bound for the Southern Pacific shops at Second and H Streets. This car is about to leave Oak Park, but it will pass through the neighborhood of Curtis Park before returning downtown. This photograph was taken on June 16, 1937, by Addison Laflin.

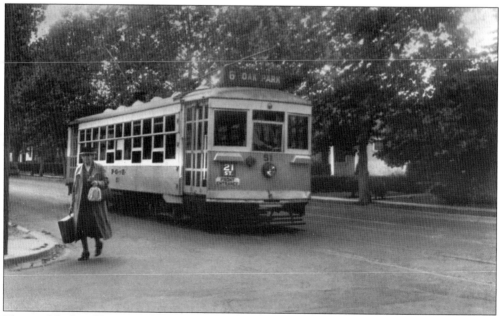

This neighborhood began as Highland Park, a name that may have suggested relief from Sacramento's problems with flooding, in the 1880s. The Highland Park Railway was a horse-drawn system, absorbed into the consolidated system that became SEG&R in the 1890s. After 1900, more of the neighborhood was built up and the area became known as Curtis Park. This photograph was taken by E. L. Estacaille.

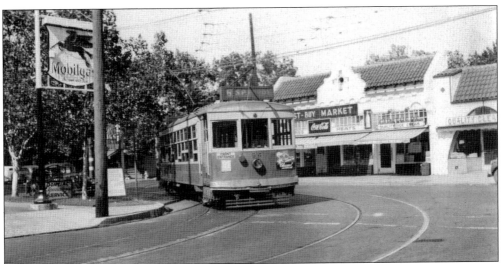

Streetcars passed through Curtis Park via routes originally built for the Highland Park Railway. This route took some odd curves, like this one on Fifth Avenue in front of Gunther's Ice Cream and the Best-Buy Market on Franklin Avenue. From here, the car turned north onto Twenty-fourth Street, then west onto Second Avenue, and then north again onto Twenty-first Street, past Christian Brothers School and St. Joseph's Cemetery.

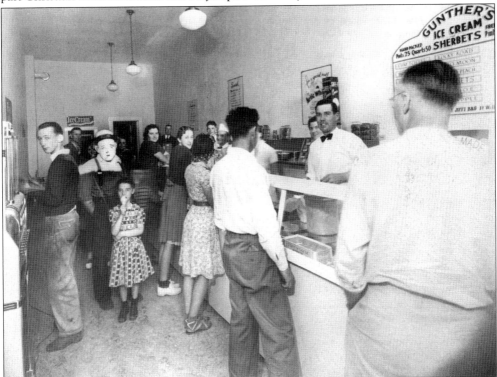

Gunther's Ice Cream opened in 1940 at its original Franklin Avenue location. This photograph was taken shortly after the store opened for business. In 1949, Gunther's relocated to Third Avenue and Franklin Boulevard. It is still open for business today and is just as popular on a hot Sacramento summer day. (Grant Hess collection.)

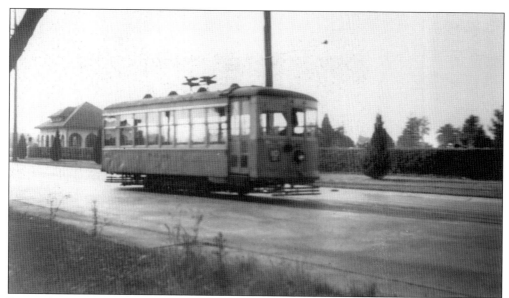

Route No. 7 was the Tenth Street–Land Park route. Here a single-truck Birney passes the Odd Fellows cemetery on Riverside Boulevard at the northern end of Land Park. All of Sacramento's city cemeteries were served by nearby streetcar lines, but PG&E did not have a funeral car like some cities' streetcar companies. Across the street from the cemeteries on Riverside was Edmonds Field, home of the Sacramento Solons baseball team.

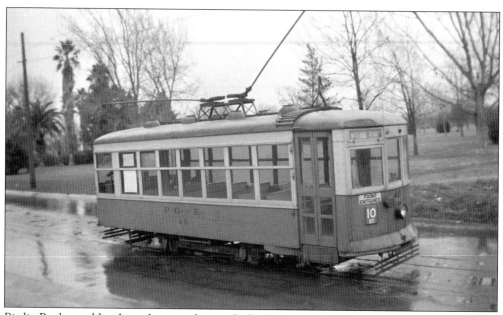

Birdie Boyles and her housekeeper often took the T Street car to Tenth Street and transferred from the Tenth Street car, like the one above, to Y Street to attend Solons games. Typically both cars would be the smaller Birney cars, which Birdie called "jitneys," but on game days, the larger two-truck streetcars would often be used on these routes.

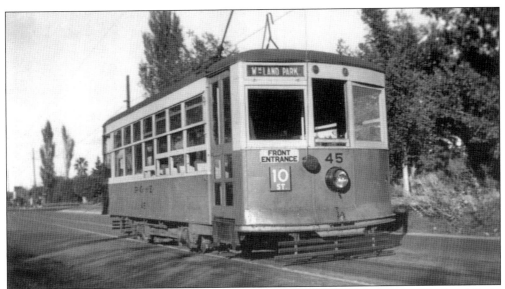

The single-truck Birney was the preferred streetcar for lightly traveled routes like Land Park. Al Balshor called these small cars the "Toonerville Trolley," which refers to a popular comic strip of the day. These lightly traveled routes were among the first to be replaced by bus lines in the 1930s.

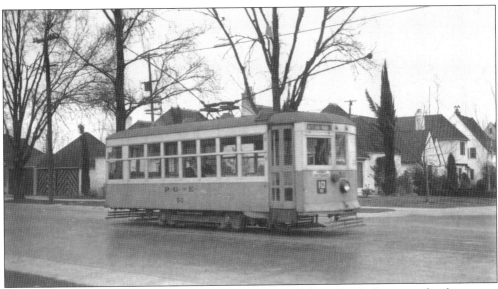

Route No. 7 served commuters living in Land Park and along Tenth Street in the downtown neighborhood of Southside Park. The line ran up Tenth Street to J Street and terminated downtown at Second and H Streets. This was a convenient commute for anyone who worked downtown along J or K Streets, at city hall or the state capitol, or the Southern Pacific shops.

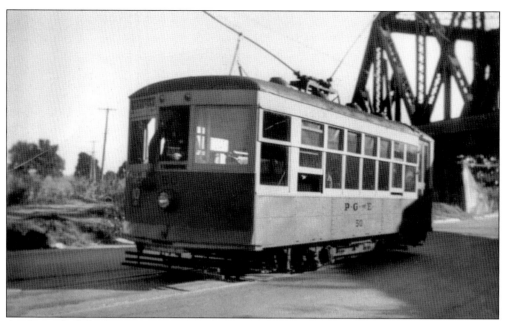

At the end of the line, PG&E Car No. 50 reverses poles. The bridge in the background is a Southern Pacific railroad bridge. Their Walnut Grove branch ran from downtown Sacramento to Isleton. William Land Park is a short walk south from this point, and across the street are the Sacramento public baths.

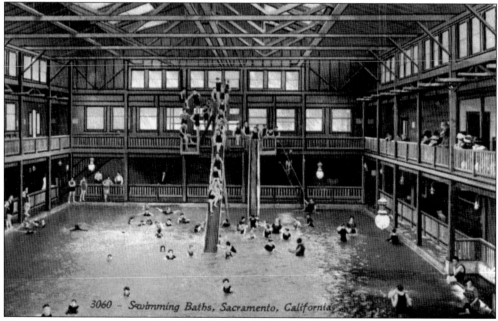

3060 - Swimming Baths, Sacramento, California

The public baths were located at the end of the Riverside Boulevard line on land now occupied by the B'nai Israel synagogue. The baths were reportedly fed by Artesian wells, but according to Birdie Boyles, many assumed it was just river water piped in from the nearby American River. The baths were only open to white people. According to Al Balshor, "If you had a suntan, you couldn't get in." (Alex Ives collection.)

72

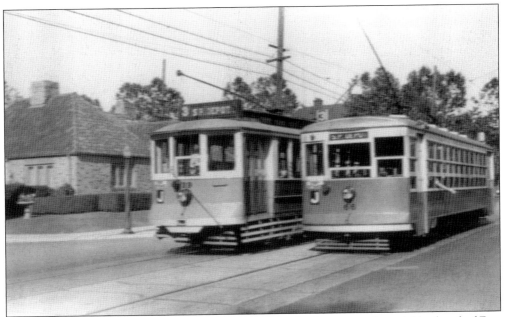

Route No. 3 ran down J Street from the Southern Pacific depot into the neighborhood of East Sacramento. Originally a farming neighborhood, East Sacramento grew into a neighborhood of large and elegant homes. Route No. 3 was converted to bus operation around 1939, but during the Second World War, streetcar service was reinstated in order to conserve gasoline.

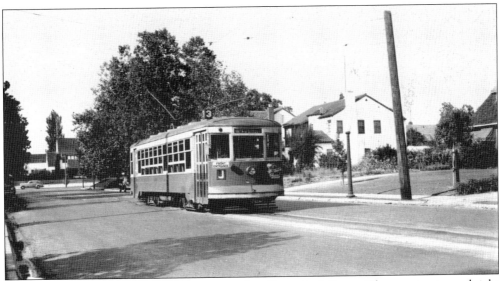

Route No. 3, in its resurrected form, terminated on Forty-sixth Street. The streetcar turned right off J Street and changed poles in the middle of the street. Other than the lack of streetcar tracks and overhead wire, the corner of Forty-sixth and J Streets looks much like it did in the days of the streetcar. Forty-sixth Street is part of the neighborhood called the "Fabulous Forties," known for the dramatic architecture of its homes.

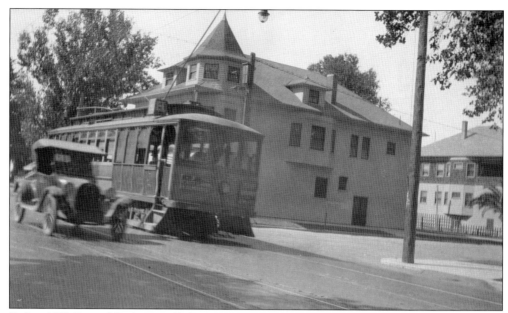

Before 1939, Route No. 3 went all the way to Forty-eighth and V Streets in Elmhurst. The track ran via Forty-sixth Street through East Lawn Cemetery, parallel to the Southern Pacific tracks on R Street, and turned south again at Forty-eighth Street. This line passed near the Coloma School on T Street. Forty-eighth and V Streets were also one block away from a rear entrance to the California State Fairgrounds.

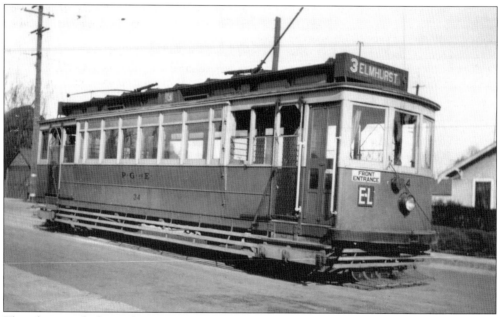

This photograph shows the original end of the line at Forty-eighth and V Streets. Route No. 3 was also known as the E–L, for East Lawn Cemetery, or Elmhurst. Plans existed around 1910 to connect the Elmhurst line to the T Street line at Twenty-eighth Street, but this plan was never completed. This photograph was taken in 1934 by Charles Smallwood.

# Six

# SACRAMENTO NORTHERN

In the first decade of the 20th century, two electric interurban railroads came into Sacramento from opposite directions and later united into a single line. From the north came the Northern Electric, running from Chico to Sacramento and across the Sacramento River to Woodland. From the southwest came the Oakland, Antioch & Eastern, which ran from Oakland to Sacramento, crossing Suisun Bay on a unique ferry named the *Ramon*. In 1928, the two railroads combined into a single entity—the Sacramento Northern.

Interurban lines filled the gap between streetcar lines and steam railroads, carrying passengers and freight between nearby cities. Their cars were larger and faster than streetcars and often ran in multiple-unit trains. Their amenities were often more like steam railroads, with restrooms, observation cars, and dining cars. Dining service on the Sacramento Northern's observation cars and a diner onboard the ferry *Ramon* were operated by Sacramento restauranteur George Dunlap, who later owned Dunlap's Dining Room in Oak Park. In addition to their amenities, interurban trains offered fast service between cities. Express trains like the *Comet* and *Meteor* ran from Chico to Oakland in five hours. Interurban railroads often provided local streetcar service for the cities they served as a provision of their charter to run on city streets. Sacramento Northern and its predecessor lines ran streetcars in Chico, Marysville, and Yuba City and multiple lines in Sacramento.

Sacramento Northern ran two main lines in Sacramento: a passenger line through downtown and a belt line that ran around the perimeter of town. Sacramento Northern's city streetcars used parts of both routes to carry passengers within Sacramento. Outside the city limits, Northern Electric, and later Sacramento Northern, streetcars carried commuters to outlying communities and nearby cities, including North Sacramento, Del Paso Heights, Swanston, Rio Linda, Elverta, and West Sacramento. These lines were often directly subsidized by real estate developers who wanted the advantages of streetcar service for the residents of their new neighborhoods.

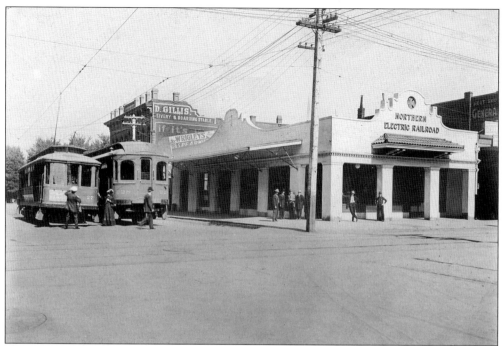

Northern Electric's interurban passenger trains entered Sacramento from the north at Eighteenth Street and took a winding path through downtown Sacramento, ending at this station on Eighth and J Street. In 1907, Northern Electric began local streetcar service in Sacramento, running from the passenger depot to Thirty-first Street via C Street. The car on the right is a Niles interurban car, with the local streetcar on the left.

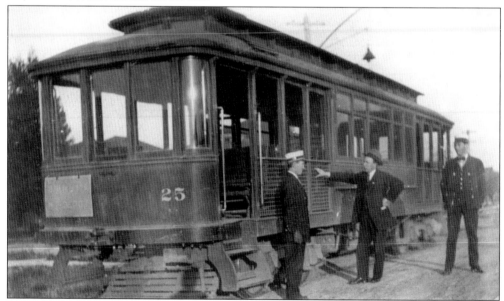

Northern Electric's original streetcars were California cars, built by the St. Louis Car Company between 1905 and 1911. They were similar in appearance and style to the Los Angeles Railway "Huntington Standard" cars. In this 1914 photograph, Northern Electric Car No. 25 waits at the eastern edge of the line at McKinley Park. W. W. Nelson is leaning against the car.

The Northern Electric included many smaller subsidiary companies. Here a streetcar lettered for the Vallejo & Northern passes city hall on I Street, traveling from the Western Pacific depot on J Street and Nineteenth to the M Street Bridge. The Vallejo & Northern never actually reached Vallejo and was integrated into the Northern Electric in 1915.

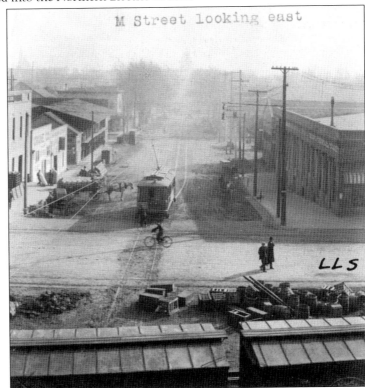

The state capitol is barely visible in the distance of this photograph taken from the M Street Bridge. This was the end of the line for the Vallejo & Northern streetcar, but interurban trains bound for Oakland or Woodland continued over the bridge.

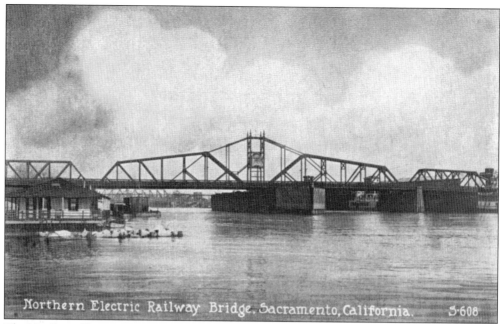

Northern Electric Railway Bridge, Sacramento, California. S-608

The Northern Electric main line crossed the Sacramento River on the M Street Bridge, built in 1909. The bridge was built for Northern Electric's branch from Sacramento to Woodland. Outriggers nine feet wide were installed on either side of the bridge for pedestrians and automobiles, but it became insufficient for traffic and was replaced by the Tower Bridge in 1935.

On December 7, 1913, the Northern Electric began streetcar service to West Sacramento, contracted by the West Sacramento Company, who sought to develop the western bank of the Sacramento River. Northern Electric built and operated this streetcar line and operating deficits were paid by the West Sacramento Company. In 1914, the West Sacramento line was combined with the Sacramento line for through service from West Sacramento to McKinley Park.

The West Sacramento Company had plans to build a railroad, incorporated as the West Side Railroad Company, as far south as Rio Vista, but rails were only constructed to about 600 feet from this station in West Sacramento. Instead, this line connected to the Oakland, Antioch & Eastern, which already ran trains to the southwest.

The offices of the West Sacramento Company are visible in the background of this photograph of the West Sacramento passenger station and Northern Electric Car No. 26. In 1924, the West Sacramento Company ended its subsidy of passenger service, and the streetcar runs to West Sacramento ended.

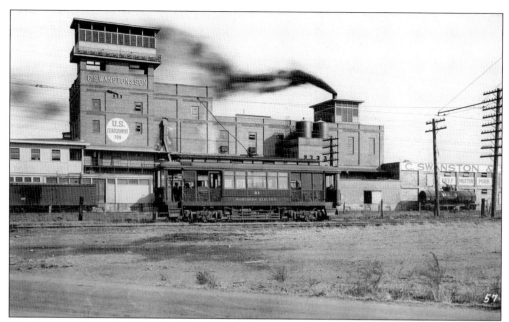

The Swanston branch of the Northern Electric opened in 1913 and ran from the main line near Globe Iron Works to the Swanston meatpacking plant along what is now Arden Way, a distance of 4.3 miles. The North Sacramento Land Company, who was developing the area, paid the Northern Electric a subsidy to provide passenger service to their new developments in North Sacramento. This view of Swanston is from 1915.

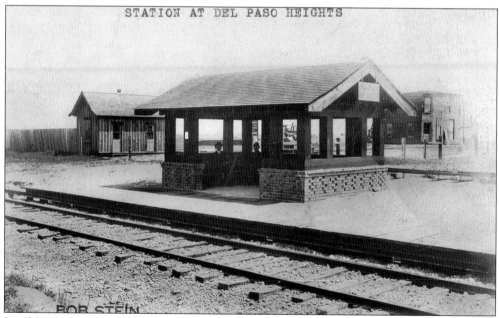

In addition to Swanston, suburban service was extended up the Northern Electric main line to Del Paso Heights, Robla, Rio Linda, and Elverta. These stations were served by the regular interurban passenger trains, but a special passenger service for commuters and high-school students was established. Since there was no high school in Rio Linda, the county provided $5 a month per student for transportation to Sacramento for school.

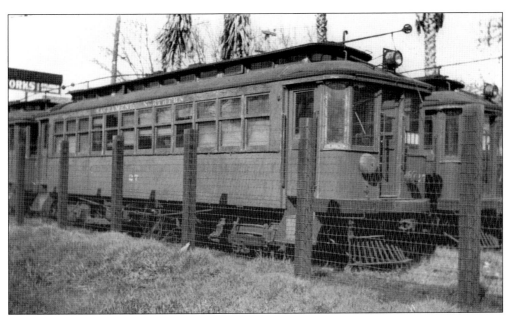

Sacramento Northern modified several of their Los Angeles streetcars for this service. They were fully enclosed, train doors were cut into the ends, and headlights were installed. Railroad pilots replaced the safety fenders. They were also modified to run as multiple-unit trains, if needed. This turned the streetcars into miniature interurban cars, known as the "Elverta Scoots." They were also used on the Swanston branch.

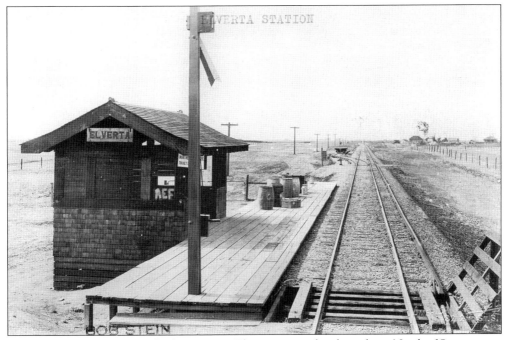

Elverta was the last stop for suburban service. There is no overhead wire here. North of Sacramento, the trains were powered by a third rail, visible along the right, which carried 600 volts of electricity. A metal shoe on the side of a truck ran along the rail to pick up current instead of using an overhead wire.

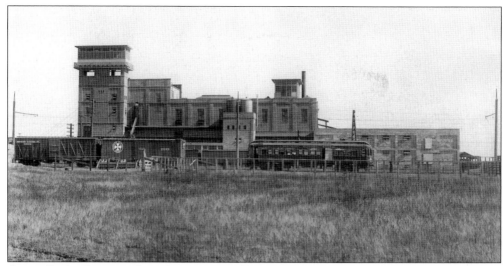

Generally the Swanston branch was serviced by Northern Electric's streetcars and the Scoots, but sometimes their larger interurban cars were used. Here combination Car No. 201 waits at the Swanston meatpacking plant. In 1933, most of the North Sacramento Land Company's lots had been sold, and the developer stopped providing a subsidy. Passenger service on the Swanston branch and the Elverta run ended shortly thereafter.

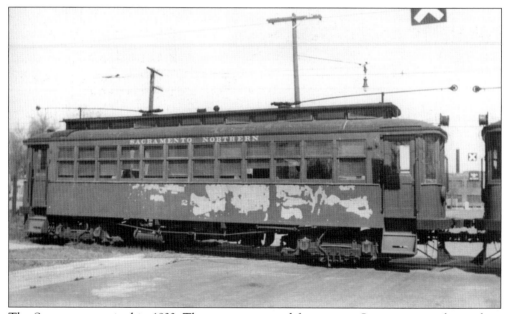

The Scoots were retired in 1933. The cars were stored for years in Sacramento at the yard on Seventeenth and D Streets but were eventually scrapped at the Chico shop. Students in Elverta and Rio Linda took a bus to school in Sacramento until 1962, when the Rio Linda senior high school was completed.

The Rio Linda passenger station was sold after the abandonment of passenger service and moved several blocks away. It still stands as a private residence, as seen in this photograph. The town of Rio Linda has created a reproduction of the Rio Linda passenger and freight station, which stands along the former Sacramento Northern main line. (Author's collection.)

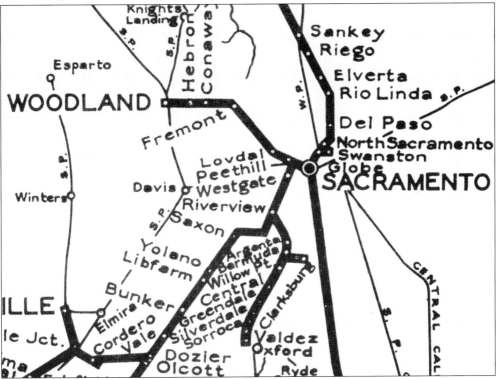

This map of the Sacramento Northern route shows the lines in the vicinity of Sacramento. The main line continued through to Chico via Marysville and Yuba City in the north and south to Oakland via Pittsburg and Walnut Creek. The tiny Swanston branch can be seen, as well as the stops for Del Paso, Rio Linda, and Elverta on the main line. (Author's collection.)

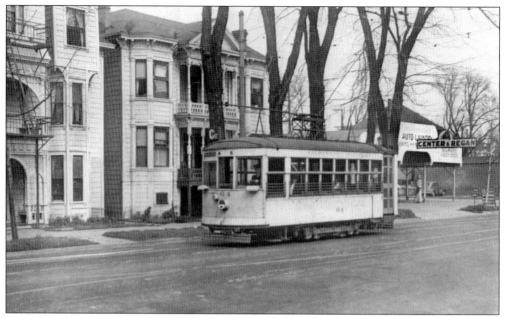

To replace the cars used on the Swanston and Elverta runs, the Sacramento Northern purchased several single-truck Birney safety cars from the San Diego Electric Railway in 1923. These cars were very similar to the PG&E Birney cars. When they needed maintenance, these cars were driven to the company shops in Chico via the Sacramento Northern's main line. E. L. Estacaille captured Birney No. 64 on March 16, 1941.

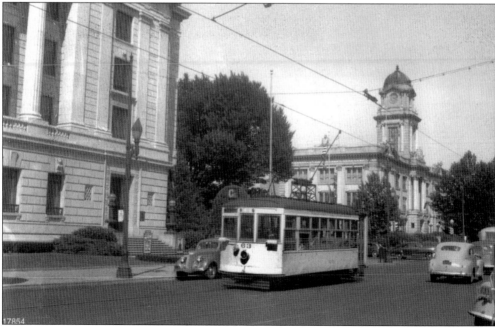

These Birney cars ran along the same route as the earlier streetcars: from Eighth and K Street in a winding path to C Street and Eighteenth and down C Street to Thirty-first Street, with a final stop at McKinley Park. Here SN Birney No. 63 trundles past city hall and the new federal courthouse, which is now a post office, along I and Ninth Streets.

84

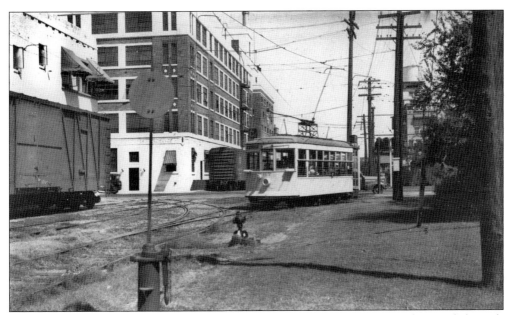

Because the Sacramento Northern also carried freight, much of their track passed through industrial areas like this one at Eighteenth and C Street. In the background are the California Almond Grower's Exchange building and the Golden State Dairy, two industries served by the Sacramento Northern.

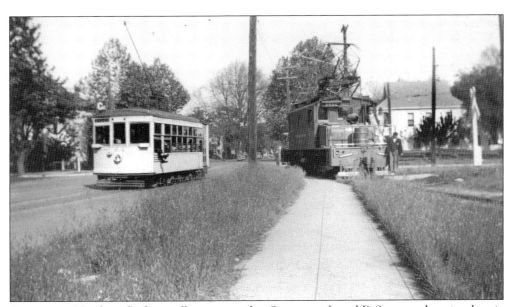

Sacramento Northern had a small service yard at Seventeenth and D Streets, where its electric freight motors and other equipment were stored. There was also a small freight station at this site. The tiny Birneys often had to share the rails with big electric locomotives, like this Baldwin-Westinghouse steeple cab.

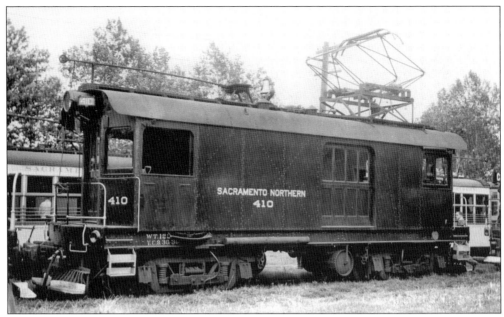

At the Seventeenth and D Streets yard, the SN Birneys were stored in between runs, as were freight motors and interurban cars. Here Sacramento Northern box motor No. 410, built by the Northern Electric shops in Chico, dwarfs a pair of Birney streetcars.

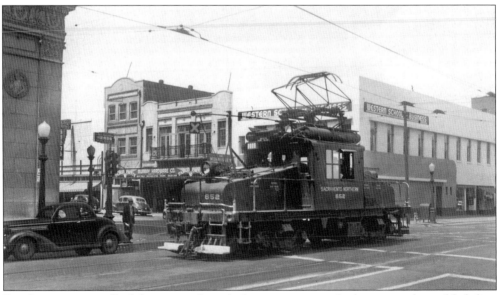

Freight trains normally did not pass through downtown, instead taking an industrial belt line around the edge of town via C, Thirty-first, X, and Front Streets and leaving town via the M Street Bridge. This photograph shows a rare exception, General Electric steeple cab 652 crossing J Street on Eighth.

In 1925, a union station was built to serve Sacramento's interurban lines. Located between Eleventh and Twelfth Streets just south of H Street, the alley in front of the station was renamed Terminal Way. The Oakland, Antioch & Eastern (then known as the San Francisco-Sacramento Railroad) and the Sacramento Northern shared this terminal with the Central California Traction's interurbans. The union station closed in 1941 at the end of SN's interurban passenger service.

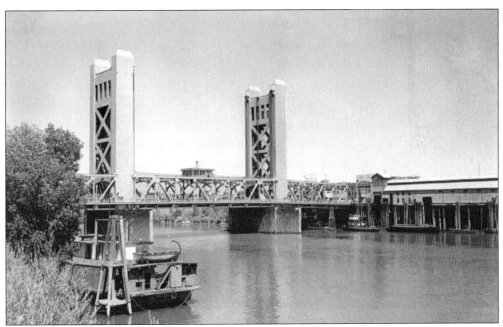

In 1935, the M Street Bridge was replaced by the Tower Bridge. As a child, Al Balshor would ride his bicycle from Southside Park to the Tower Bridge whenever he heard the horn of approaching riverboats. Al and his friends would ride the center span of the bridge as it rose to allow boats to pass underneath. Interurban and freight trains ran down the center of this bridge.

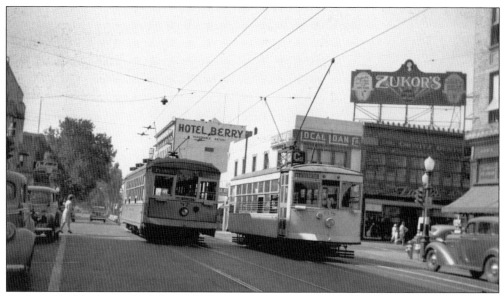

At the end of the line at Eighth and K Streets, Sacramento Northern streetcar passengers could transfer to the Central California Traction car, which continued south down Eighth Street, or the PG&E cars on J or K Streets. This was the only place where cars of all three companies met at a common point.

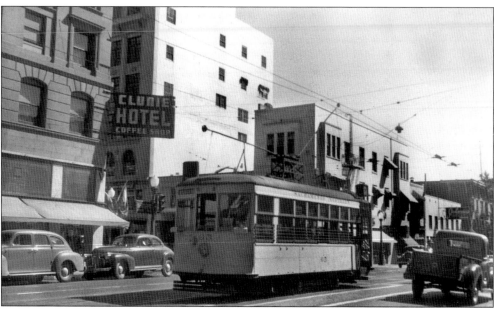

All three companies offered free transfers between lines, which became a point of contention when CCT and PG&E raised their rates to 7¢, but SN kept their rates at a nickel. Riders could board an SN car for 5¢ and then transfer to another company's car, saving 2¢ a ride.

# Seven

# CENTRAL CALIFORNIA TRACTION

Sacramento Northern was not the only interurban railroad to reach Sacramento. Central California Traction ran from Stockton to Sacramento and, like the Sacramento Northern, provided local streetcar service. The CCT streetcar system was intended to serve two neighborhoods on the southern edge of Sacramento—Colonial Heights and Colonial Acres—and provide commuter service to the central city. These neighborhoods were built along the CCT main line on Stockton Boulevard between Twenty-first Avenue and the street now known as Broadway.

The streetcar line followed the route of interurban trains on Stockton Boulevard past the California State Fairgrounds, down Second Avenue to Sacramento Boulevard (now Broadway), up Thirty-first Street (now Alhambra Boulevard), and joined the Sacramento Northern freight belt line on X Street. On Eighth Street, the line turned north along Southside Park, terminating at the CCT passenger terminal at Eighth and K Streets. Here passengers could transfer to Sacramento Northern cars or to PG&E cars on K Street.

Central California Traction stopped offering interurban service in 1933 but continued carrying streetcar passengers until their streetcar system was sold to National City Lines in 1943. CCT switched to diesel-electric operation in 1946 and continued carrying freight through Sacramento's city streets until the closing of the Sacramento belt line in 1966. After that date, CCT entered Sacramento via Southern Pacific's right-of-way until 1998. They are still a functioning railroad, servicing the Port of Stockton.

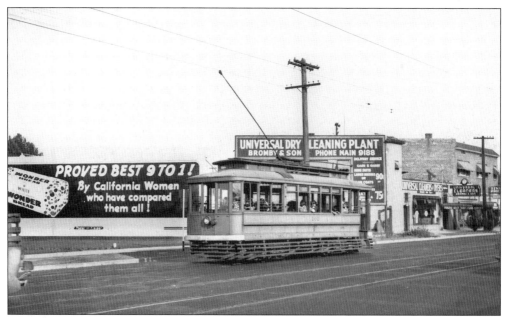

This CCT streetcar carried passengers from Colonial Heights to Eighth and K Streets via Twenty-first Avenue, Stockton Boulevard, Second Avenue, Sacramento Boulevard, Thirty-first Street, X Street, and up Eighth Street to the downtown terminal. Here it is running on Sacramento Boulevard near Thirty-second Street.

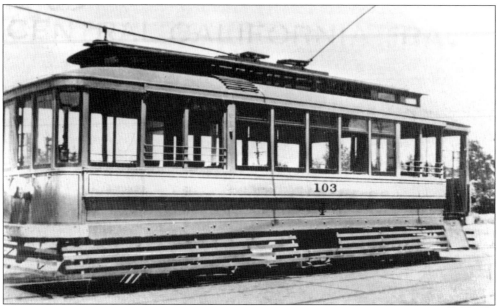

The original Central California Traction streetcars were built in 1906 by the St. Louis Car Company. They superficially resembled the Los Angeles–style cars built for Northern Electric, except they were slightly smaller. Like the PG&E cars, they were originally semi-open California cars, later enclosed for one-man operation.

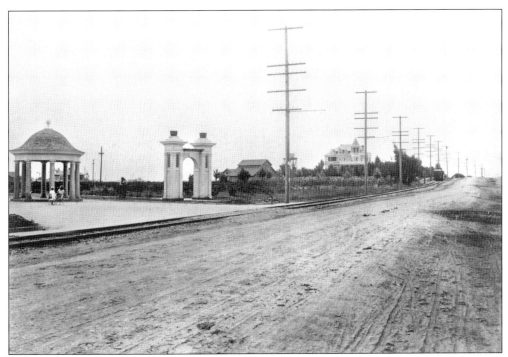

This early view of the CCT main line along Stockton Road (now Stockton Boulevard) shows a pavilion built by the Colonial Investment Company, a development firm owned by Walter Arnstein, Samuel L. Napthaly, and Simon Scheeline. The first two were Central California Traction employees, and Scheeline was the brother-in-law of Mortimer Fleishhacker, chairman of the board of CCT. (Grant Hess collection.)

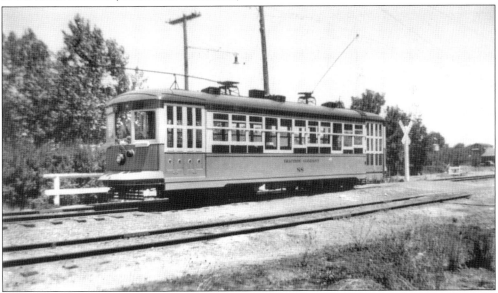

In 1939, Central California Traction purchased several two-truck Birney streetcars from Fresno Traction Company to replace their older St. Louis cars. These cars were similar to the PG&E two-truck Birneys, except these new Birneys had four traction motors instead of two. As a result, these cars were quicker than the PG&E cars.

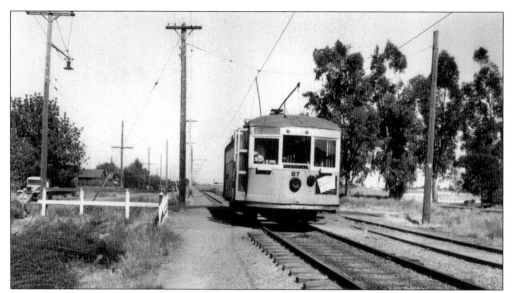

Interurban trains and freights coming from Stockton entered Sacramento from the south, but streetcars stopped here at Twenty-first Avenue and Solano. The small white fence in the above photograph marked the last stop on the CCT streetcar route.

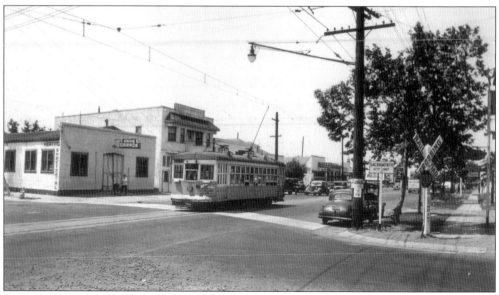

From the end of the line on Twenty-first Avenue, CCT streetcars turned north on Stockton Boulevard and entered Sacramento city limits at Fourteenth Avenue. This brought the streetcar from Colonial Acres to Colonial Heights. By the time of this photograph, c. 1940, Colonial Heights was no longer farmland with a lonely pavilion marking the spot where a neighborhood would someday be built.

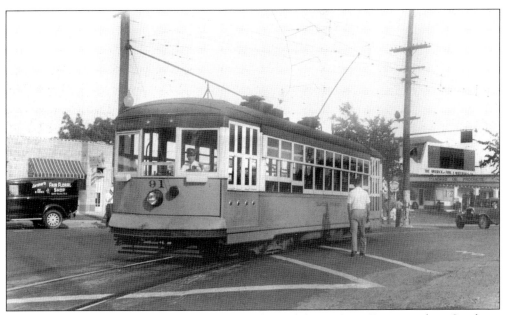

The Traction Company's main line went past the California State Fairgrounds at Stockton Boulevard and Broadway. Local passengers could take the Traction Company streetcar to the state fair instead of the PG&E car, which traveled on a slower, less direct route through Oak Park. Here a streetcar pulls onto Second Avenue from Stockton Boulevard, about two blocks from the fairgrounds. (Grant Hess collection.)

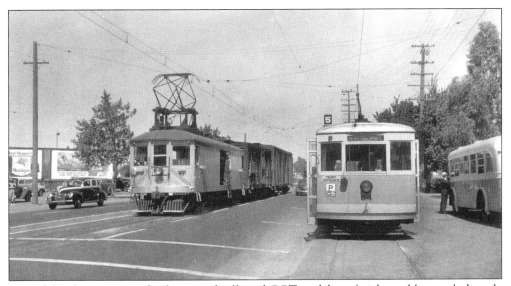

Several freight spurs into the fairgrounds allowed CCT to deliver freight and livestock directly to the fairgrounds site, a job it continued until 1966 when the fairgrounds were moved to the Cal Expo grounds and CCT tracks were removed from Sacramento streets. CCT box motor No. 6, pulling a pair of stock cars, passes a PG&E streetcar and passenger bus parked outside the fairgrounds on Stockton Boulevard.

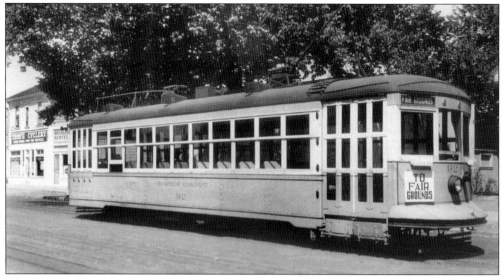

This car is on Second Avenue, just past Thom's Cyclery and Thirty-fourth Street. The building housing Thom's Cyclery was originally built in 1895 and housed Daly Brothers Groceries and Provisions. Thom's Cyclery is still open in the same location, and a piece of CCT track is still visible in the street on Thirty-fourth Street and Second Avenue.

Central California Traction had a carbarn and storage yard on the corner of Thirty-first and X Streets. Here two of the older St. Louis cars are parked near the barn, with a newer Birney in the middle. Freight cars were also stored here.

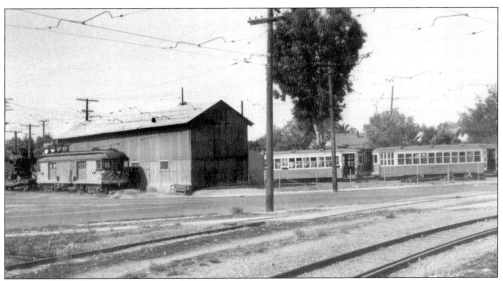

CCT's box motors, like the one on the left in this photograph, were also stored at this yard. Box motors were electric freight motors built to carry cargo inside their chassis, in addition to pulling freight cars behind them. Since the motors of an electric freight engine are underneath the body and there is no diesel engine or steam boiler, the body of a box motor is mostly empty.

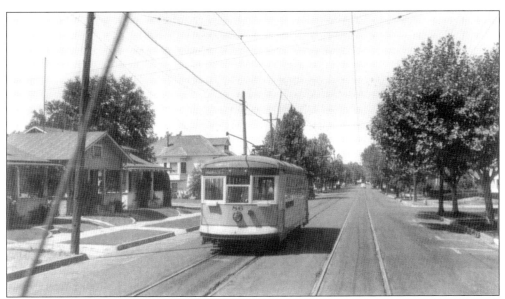

From the carbarn, the CCT streetcar line followed X Street. The double track allowed trains traveling in opposite directions to pass each other. This was important on a line like X Street, where a streetcar might find itself sharing the track with a freight train moving cars between interchange points or industries along the industrial belt line.

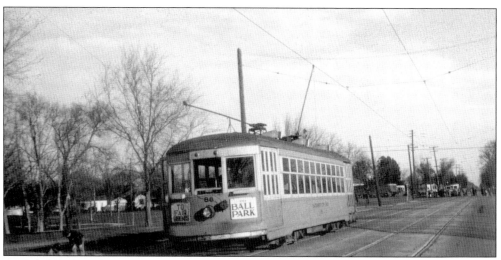

At Eighth Street, the cars turned north and ran past Southside Park. Although this car is carded for the "Ball Park," the closest the CCT cars came to Edmonds Field was a block away at X Street and Eleventh. Many passengers still rode these cars to baseball games, though, because the PG&E cars were full on game days.

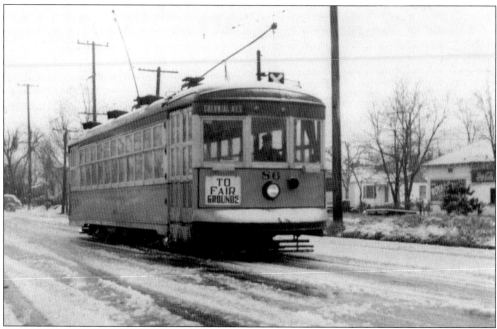

Snow in Sacramento is an extremely rare occurrence, but on March 19, 1942, photographer Larry Harrison captured this scene of morning snowfall along the CCT's right-of-way. Fortunately this snowfall was very light and did not require street clearing. No Sacramento streetcar company owned a snow sweeper!

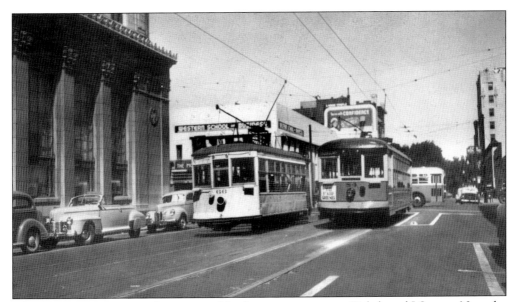

The CCT streetcar met its Sacramento Northern counterpart at Eighth and J Streets. Note the J Street city bus behind the streetcars. From this point, commuters could transfer to a PG&E streetcar or bus or the SN streetcar. This was also the location of Central California Traction's original passenger station, across the street from the Sacramento Northern station.

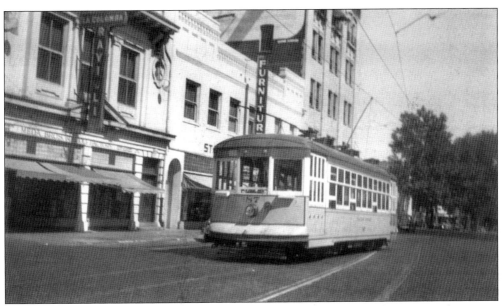

A CCT streetcar has switched tracks, reversed poles, and is ready to depart near the corner of Eighth and I Streets. At the time, this was as far north as the CCT streetcars came, and then only to change tracks. After 1943, these cars would travel farther, although under different ownership.

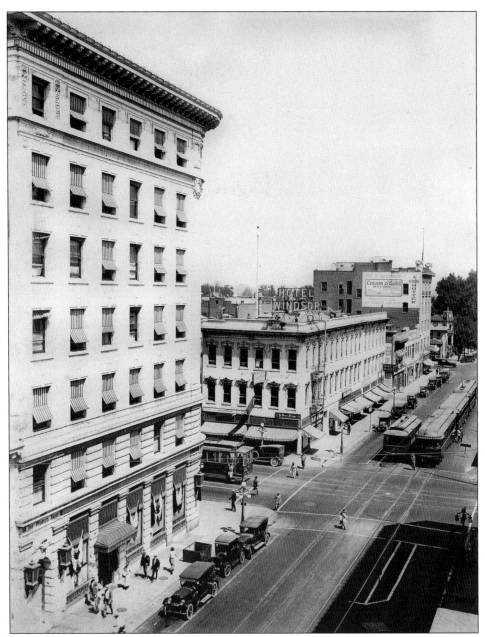

Central California Traction and Sacramento Northern provided streetcar service in Sacramento, but their main business was interurban freight and passengers. In this photograph of Eighth Street, taken from a high vantage point near L Street, a three-car Sacramento Northern interurban train is visible. The rear car on the train is the observation car *Bidwell*, a luxury car with its own kitchen and a private observation deck. Observation cars were a feature of the SN's main line trains. Also visible at the corner of Eighth and K Streets are a Central California Traction streetcar, dwarfed by the interurban train, and a PG&E streetcar on K Street. Even after SN and CCT relocated their interurban passenger stations to the union station on H Street, the corner of Eighth and K Streets remained a central transfer point for the city streetcar system until the end of streetcar service.

*Eight*

# SACRAMENTO CITY LINES

In 1935, Pres. Franklin Delano Roosevelt signed the Public Utility Holding Company Act in an effort to restrict the influence of large utility companies like PG&E. The act prevented utility companies from owning and managing more than one utility at the same time. This act meant that PG&E, an electric and gas utility company, could no longer own a streetcar company. The streetcars continued under PG&E's ownership until 1943, when the streetcar system was purchased by Pacific City Lines, a division of National City Lines.

National City Lines was incorporated in 1936 and quickly began buying streetcar systems throughout the United States. Eventually they controlled about 10 percent of the nation's streetcars still in operation. While seeking capital to purchase more streetcar lines, the company sold stock to General Motors and Firestone Tire and Rubber. Other NCL investors included Phillips Petroleum, Standard Oil, and Mack Truck.

Even before the change of ownership, PG&E had already started converting streetcar lines to buses. Many American cities had already lost their streetcar systems to the Depression, poor management, or lack of ridership. Sacramentans, like most Americans, also eagerly adopted the automobile. According to Birdie Boyles, as soon as she could afford her own car she stopped riding the streetcar. Al Balshor preferred his three-wheeled motorcycle to riding the streetcar for making deliveries, even if he had to pay the occasional traffic ticket. Especially in the years following World War II, the people of Sacramento wanted to enjoy luxuries deferred during the war years, including private automobiles.

After the war years, Sacramento grew in all directions, and unlike the development of earlier eras, a streetcar line was no longer an incentive to residential customers. Instead, easy access to freeways became the selling point for mobility-minded Sacramento home buyers. If commuter service was needed in these new neighborhoods, a bus line could be established with a few bus stop signs and a change in schedules. All of these changes meant the end of the line for Sacramento's streetcars.

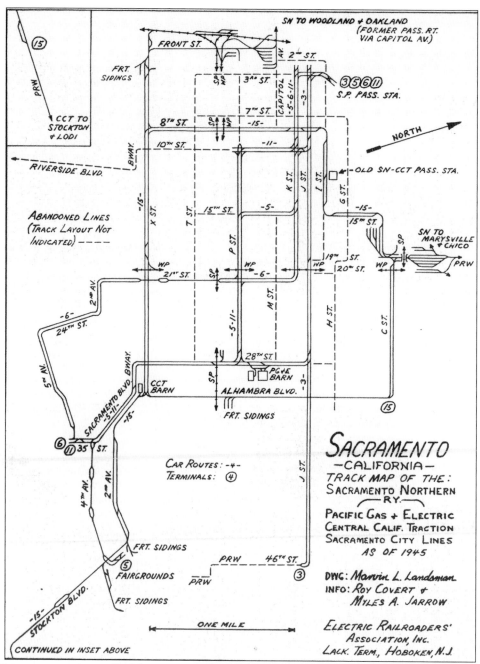

SN TO WOODLAND & OAKLAND
(FORMER PASS. RT.
VIA CAPITOL AV.)

FRONT ST.

FRT. SIDINGS

③⑤⑥⑪
S.P. PASS. STA.

NORTH

CCT TO STOCKTON & LODI

RIVERSIDE BLVD.

OLD SN-CCT PASS. STA.

ABANDONED LINES
(TRACK LAYOUT NOT INDICATED) ----

SN TO MARYSVILLE & CHICO

PRW

SACRAMENTO
—CALIFORNIA—
TRACK MAP OF THE:
SACRAMENTO NORTHERN
— RY.—
PACIFIC GAS & ELECTRIC
CENTRAL CALIF. TRACTION
SACRAMENTO CITY LINES
AS OF 1945

CAR ROUTES: -④-
TERMINALS: ④

PG&E BARN

CCT BARN

ALHAMBRA BLVD.

FRT. SIDINGS

DWG: Marvin L. Landaman
INFO: Roy Covert &
MYLES A. JARROW

FAIRGROUNDS
PRW

FRT. SIDINGS

ELECTRIC RAILROADERS'
ASSOCIATION, INC.
LACK. TERM., HOBOKEN, N.J.

ONE MILE

STOCKTON BLVD.

CONTINUED IN INSET ABOVE

This route map shows all of the operating electric lines in Sacramento in 1945, when Sacramento City Lines operated Sacramento's streetcars. Some of the discontinued lines are pictured, and route numbers as of 1945 are labeled. This map also includes the track used by Central California Traction and Sacramento Northern, much of which was strictly freight territory, like the belt line past Eighth Street, up Front Street and Alhambra Boulevard between McKinley Park and X Street. Both SN and CCT sold their streetcar holdings to SCL, which ended both companies' passenger business in Sacramento. Central California Traction ceased interurban operation in 1933, and Sacramento Northern stopped carrying interurban passengers in 1941.

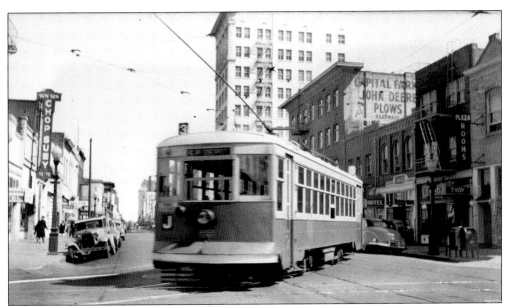

According to the December 1943 issue of *PG&E Progress*, Pacific Gas & Electric sold 33 streetcars, 60 buses, 24.7 miles of track, 2 carbarns, and a garage to Pacific City Lines. In this photograph, Car No. 65 pulls onto J Street from Third Street, displaying the Sacramento City Lines logo. The paint scheme of the cars, cream-colored at the windows and yellow below, remained the same.

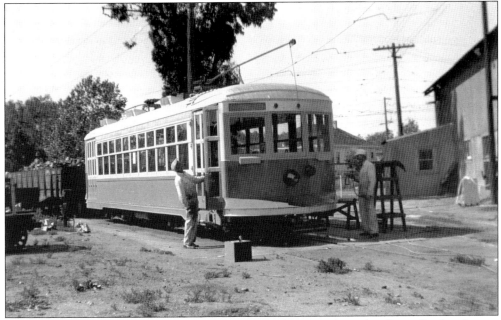

Taken on November 2, 1943, this photograph of the carbarn on Thirty-first Street (by then known as Alhambra Boulevard) and X Street shows a Central California Traction four-motor car being repainted and lettered for Sacramento City Lines. According to photographer Roy Covert, the painters in this picture were named Worell and Dare.

The former CCT cars replaced Sacramento Northern's single-truck Birneys on what had been the Sacramento Northern's downtown line. Since through track via Eighth and K Streets already existed, it was easy to combine both lines into a single streetcar run, Route No. 15. In this photograph, two double-truck Birneys pass each other on Eighth Street near L Street, two blocks south of the old crossover point at Eighth and K Streets.

Route No. 15 ran all the way from Colonial Heights to McKinley Park, with stops in Oak Park and downtown. Here a former CCT streetcar passes city hall at I Street and Tenth Street, where SN Birneys and interurban trains had run. The CCT cars, with their four motors and larger size, were more than suitable replacements for the single-truck Birneys.

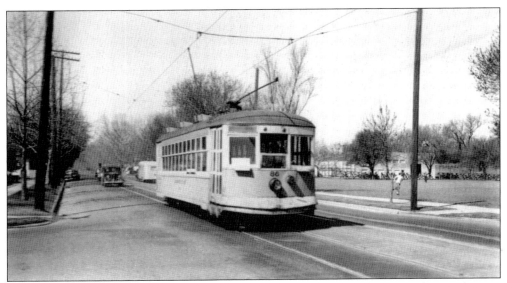

On C Street, Line No. 15 runs parallel to the Southern Pacific Railroad main line and passes through residential neighborhoods and city parks. During the Second World War, gasoline rationing seriously hampered most personal driving, which made streetcar transportation very important. Heavy traffic during the war brought business, but it also resulted in much wear to cars that were often already starting to show their age.

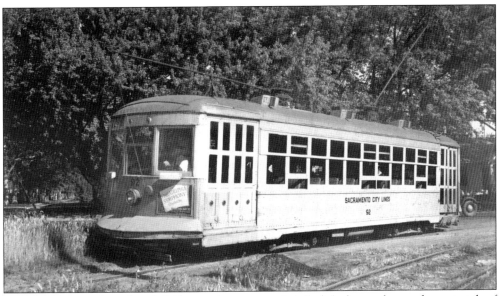

At Alhambra Boulevard and C Street, the streetcar briefly left the road on a short stretch of private right-of-way. This curve was very broad because of this route's use as a freight railroad. Railroad boxcars cannot handle the tight curves that a city streetcar can, and so the turns this car made at Alhambra Boulevard were comfortably broad by streetcar standards. By railroad standards, they were alarmingly tight curves.

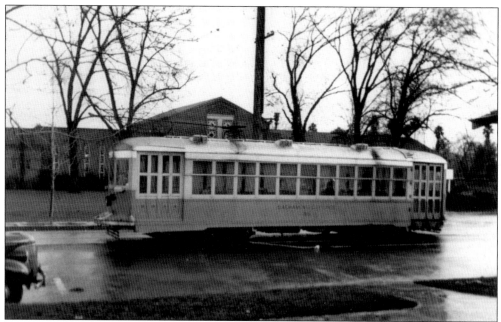

A Line No. 15 car parks at the end of the line outside Clunie Hall at McKinley Park. This hall was named for Florence Turton Clunie, who bequeathed $150,000 to the city of Sacramento to build a clubhouse and a pool at McKinley Park. The clubhouse was built in 1936, two years after Clunie's death.

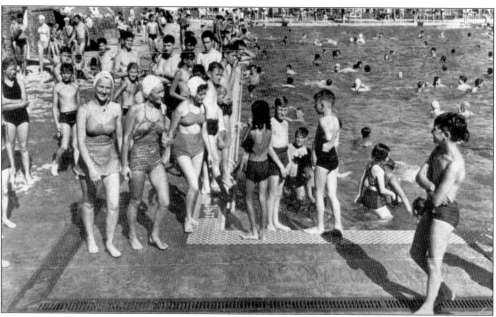

This is the pool behind Clunie Hall, funded by Florence Turton Clunie's bequest. In addition to the pool area, the clubhouse included meeting rooms and a public library. This clubhouse replaced an older wooden one that was falling into disrepair. Clunie's husband, Thomas J. Clunie, built the Clunie Hotel at Eighth and K Streets. (Author's collection.)

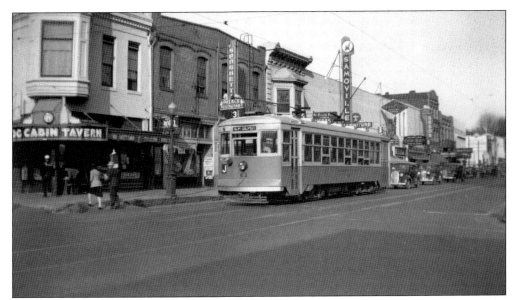

Sacramento City Lines also kept the original PG&E cars, although they also stopped using the PG&E single-truck Birneys. This Christmas car, seen on J Street at Seventh in its new SCL colors, is running on Route No. 3. This line had been discontinued and replaced by buses while PG&E was still operating the system, but gasoline shortages forced PG&E to reinstate the line as a streetcar route. SCL continued this route until 1946.

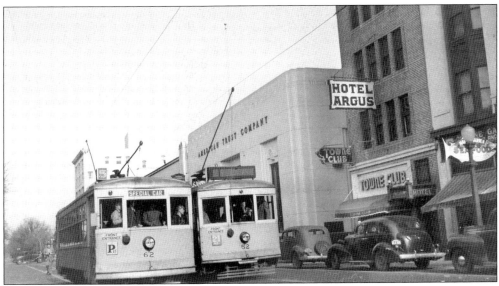

In addition to Line No. 15, Sacramento City Lines maintained four of the old PG&E streetcar lines—Line No. 3 to Forty-sixth and J Street, Line No. 5 to the fairgrounds, Line No. 6 to Oak Park via Twenty-first Street, and Line No. 11 to Oak Park via Tenth Street. All lines began at the Southern Pacific station. Here two cars meet on Tenth Street next to the Hotel Argus, between J and K Streets.

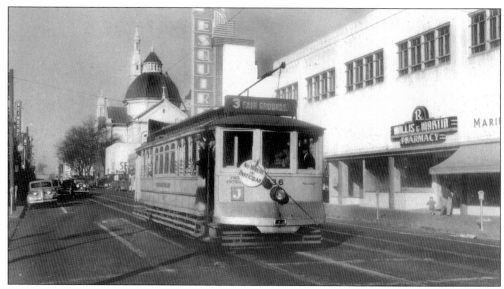

Fairground specials invariably meant confusion about what cars ran on which line. This car is carded for Line No. 3, J Street, but is running on K Street, past the Esquire Theater and Willis and Martin Pharmacy. The roller sign on the car indicates that this is a fairgrounds run, which means that any other signage on the car should be disregarded—including the "No Where in Particular" destination board.

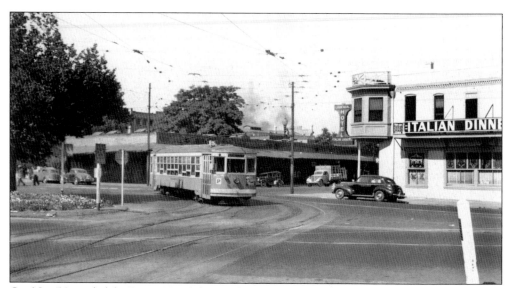

Car No. 56, carded for Route No. 5, leaves the Southern Pacific station at Third and I Streets. To the right is the Commercial Hotel, the original home of the Espanol Italian Restaurant. A wooden cannon faces the Southern Pacific yards, a reminder of the day when a Southern Pacific boxcar ran off the tracks and smashed into the restaurant.

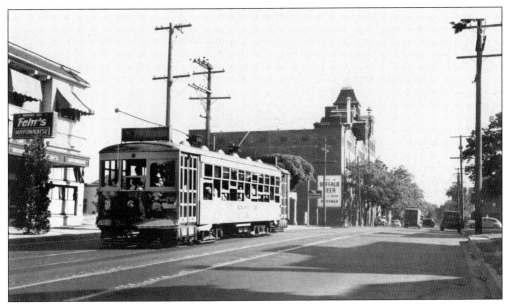

The Buffalo Brewery, like the streetcar, was also facing its last days of operation. Al Balshor briefly worked at the Buffalo Brewery after returning from the Second World War. The brewery was sold to Grace Brothers in 1942 and operated for a few years, but the plant was eventually closed and then demolished in the 1950s. The *Sacramento Bee* has its offices on the Buffalo Brewery site today.

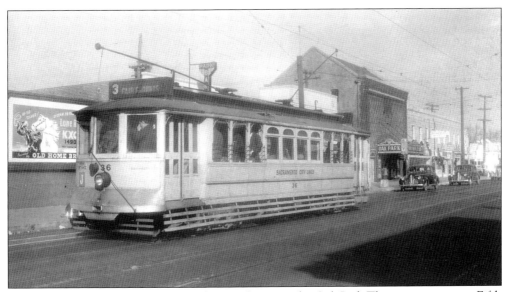

V. B. DuBrutz captured this fairgrounds special passing the Oak Park Theater on its way to Fifth Avenue. By this time, the handful of old rope-brake cars had been retired, or their rope brakes replaced with an air brake system. Most of the older wooden cars, like this 1914 American Car Company car, were used to cover days of heavier traffic, like the state fair or baseball games, but SCL relied on the double-truck Birneys for general service.

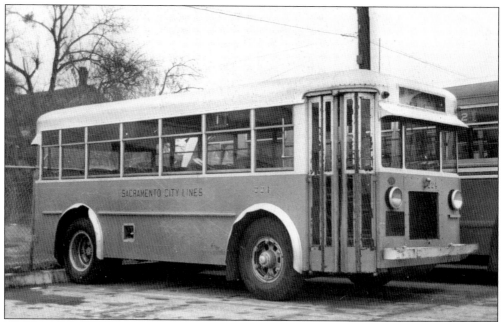

In addition to the streetcars, Sacramento City Lines also purchased the motor coaches already owned by PG&E. Among the buses purchased was this Twin Coach Model 30, built in 1932. In this 1947 photograph by E. R. Mohr, Bus No. 224 is wearing the old PG&E color scheme of yellow and cream, with a silver roof. These buses continued their role of operating on the city's less-traveled lines. (Bob Blymyer collection.)

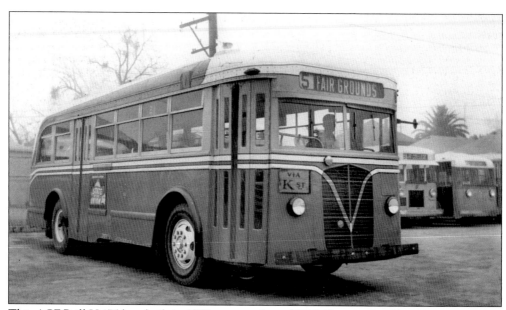

This ACF-Brill H-175 bus, built in 1937, was another of PG&E's varied stable of buses. This bus has been repainted. It is labeled for Route No. 5, the fairgrounds run once assigned to a streetcar. This 1947 photograph was taken by E. R. Mohr. (Bob Blymyer collection.)

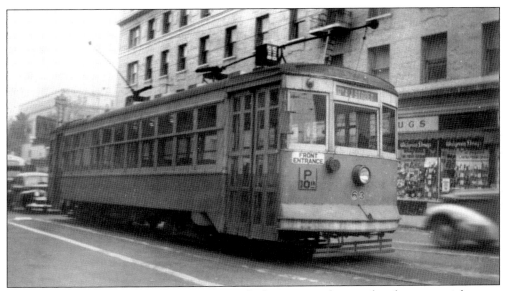

During Sacramento City Lines' tenure, paint jobs for streetcars became less frequent as it became apparent that they would not last. Wartime shortages also meant that paint was harder to obtain. As a result, the reputation of Sacramento's streetcars for cleanliness and always looking freshly painted began to tarnish. Car No. 63, pictured here in front of Walgreen's at Tenth and K Streets, looks past due for a repainting.

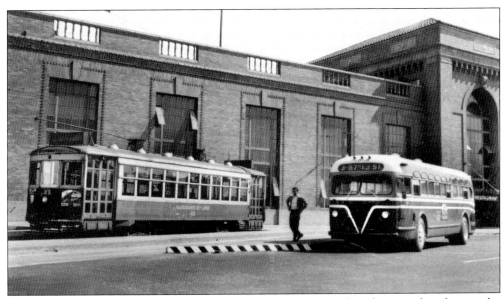

The deterioration of the streetcars' paint jobs is apparent in this photograph, taken at the Southern Pacific depot. This streetcar is only about 20 years old, but its poor paint job sits in stark contrast to the shiny new bus. Before long, the parking bays built for streetcars would be inhabited only by buses.

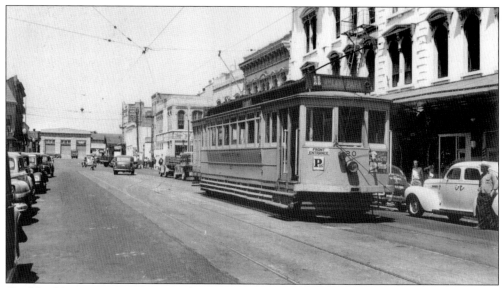

Car No. 20 is not running in regular service—it has been chartered by a group of streetcar enthusiasts who want to ride and preserve the memory of Sacramento's streetcars. Departing from the Southern Pacific station, this car is carded for Line No. 11 but will run multiple routes as part of a privately chartered fan trip.

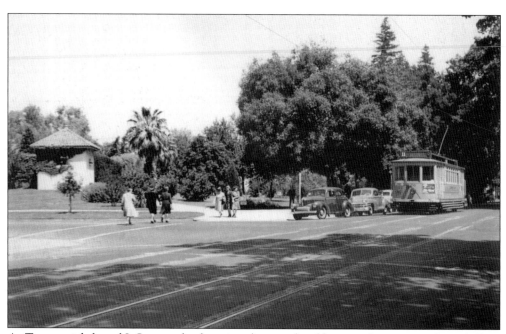

At Twenty-eighth and L Streets, the fan trip takes in a local historical attraction, Sutter's Fort. Except for one building, the fort is a reconstruction of the original. At this point in the summer of 1946, the reconstructed fort has been around longer than the original walls of the fort stood.

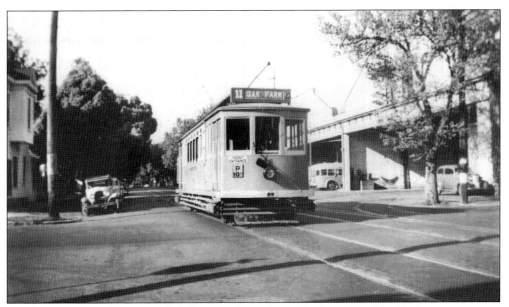

Past Sutter's Fort on Twenty-eighth Street is the carbarn. Tracks still lead inside, but no streetcars are immediately visible. The left side of the carbarn is being used to store SCL's new buses. One might safely assume that the streetcar fans in the car are alternately snapping photographs of the carbarn and booing and hissing at the buses.

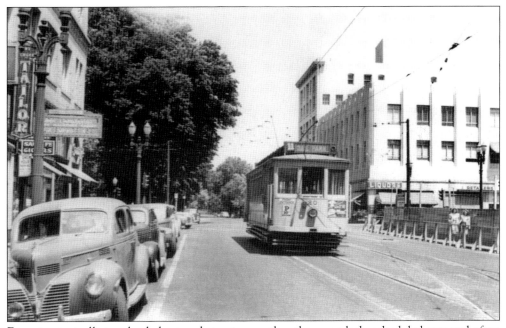

Fan trips typically involved chartered streetcars rather than regularly scheduled cars and often involved riding more than one car line. Car No. 20 has moved from K Street onto Tenth Street, past a construction site at Tenth and J Streets near Plaza Park, and is preparing to depart for the next leg of the trip.

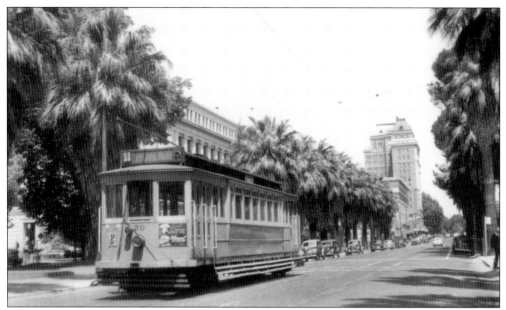

Fan trips typically involved many stops for riders to get out and take photographs of the cars in attractive settings. Here Car No. 20 passes one of the two state office buildings on the corner of Tenth Street and M Street, now Capitol Avenue, with the Cal-Western building in the background.

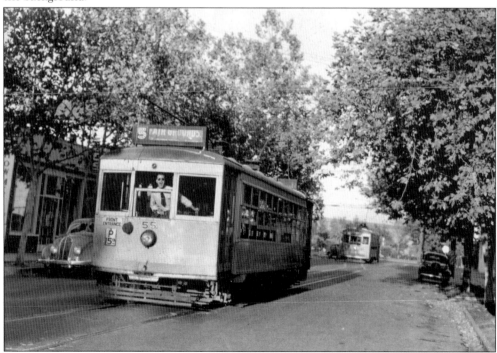

Despite rail fans' concerns about the fate of streetcars, fan trips were generally friendly and cheerful affairs. In this Roy Covert photograph from a 1946 fan trip in Sacramento, Bay Area Electric Railroad Association (BAERA) member Herb Westoff operates the controls of Car No. 55. Westoff was well known for his Pendleton shirt, sunglasses, and talkative manner.

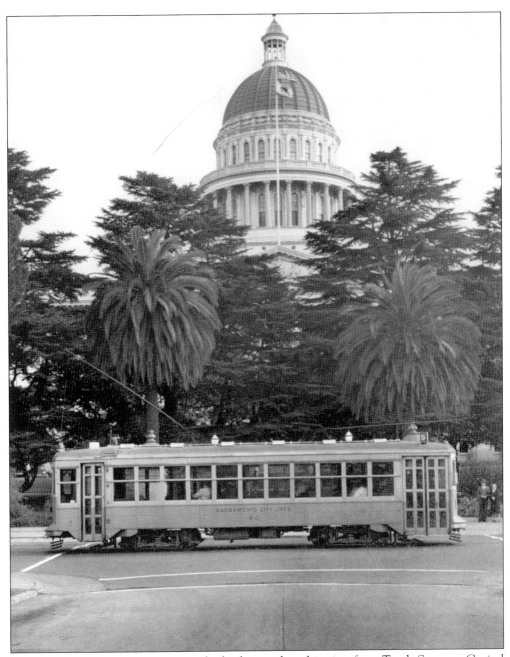

The state capitol building, rising in the background in this view from Tenth Street at Capitol Avenue, was always a popular site for streetcar photographs, whether on a fan trip or simply photographing cars in regular service. In May 1946, Sacramento City Lines requested permission to replace the last remaining streetcar lines with bus service. By October, this permission was granted, and Lines No. 3, No. 11, and No. 15 were abandoned. Lines No. 5 and No. 6 were the last remaining streetcar lines, and the newer steel Birney cars on Lines No. 3 and No. 11 were transferred to these routes. This photograph was taken during a Bay Area Electric Railroad Association farewell fan trip to Sacramento on October 20, 1946.

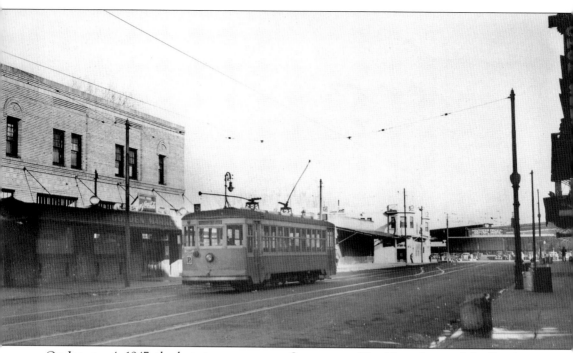

On January 4, 1947, the last streetcar run on Sacramento City Lines departed the Southern Pacific depot. Twelve BAERA members rode in the car, which ran Route No. 5 to the state fairgrounds and back. Motorman Arthur E. Stanley operated the car. He said that Sacramento would probably not be the same without the big yellow cars. Sacramento residents showed little concern about the end of the streetcar. An article in the *Sacramento Bee* that day claimed, "No longer will the motorman's clang of the warning bell, the shrill grinding of the metal wheels or the earth shaking gyrations of the lumbering cars assail your ears. Instead, the soft purr of Diesel motored passenger buses, their rubber tires caressing the asphalt in an inviting conspiracy of 'safety, comfort and convenience' will beckon quietly for your patronage." The article closed with, "Maybe there is a great beyond to which all well behaved streetcars go when they pass on. And perhaps the old horse cars of yesteryear will be waiting with an understanding welcome in that Valhalla of public transportation's dilapidated souvenirs."

# Nine

# RAIL FANS, FAN TRIPS, AND RESURRECTION

The slow disappearance of streetcars from America's streets had given rise to a group of hobbyists interested in the preservation of streetcars. Streetcar fans, sometimes known as "trolley jollies" or "juice jacks," often formed clubs and associations to share and discuss their interests. The Bay Area Electric Railroad Association was typical of these groups. Formed in 1946, BAERA members were interested in electric railroading throughout northern California, including both streetcar and interurban systems like the Key System, San Francisco's Market Street Railway, Petaluma & Santa Rosa, Sacramento Northern, Central California Traction, and Tidewater Southern. Sacramento's multiple streetcar networks were certainly part of these enthusiasts' interests.

Rail fans took photographs of streetcar systems, but they were also interested in acquiring railroad memorabilia. As streetcar and interurban systems retired their equipment or went out of service entirely, many rail fan groups started to purchase these surplus vehicles. At the time, there was not much market for old streetcars, and many were simply sold as scrap metal or, in the case of wooden cars, stripped of metal components and burned. Purchase seemed like a feasible way to preserve some of the streetcars for future use.

As collections of streetcars in rail fan hands grew, some turned into museums in their own right. The Bay Area Electric Association stored its collection at vacant Sacramento Northern facilities but eventually acquired a section of Sacramento Northern main line and built a museum around it. This museum, the Western Railway Museum, has grown to include restoration shops, archives, an operating electric tourist railroad, and carbarns to display their collection of streetcar and interurban equipment.

In more recent years, the streetcar has come back into vogue as a means of urban transit. Increased interest in central cities and the negative effects of freeway traffic have combined to bring electric rail travel back into the public eye. Initially using the euphemism of "light-rail vehicle" instead of the antiquated term "streetcar," rail has returned to many cities. In 1987, Sacramento welcomed the return, of a sort, of the streetcar.

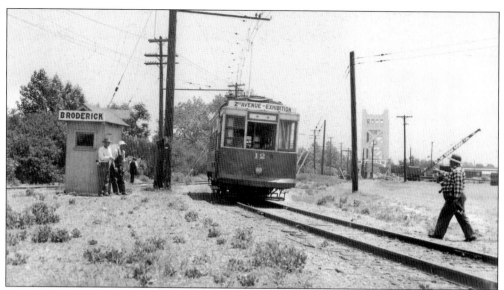

On June 3, 1951, the BAERA sponsored a special fan trip to Sacramento. Streetcar service had ended more than four years earlier, but Sacramento still had an electric railroad system in place—the Sacramento Northern's belt line. The trip began here at Broderick, directly across the Sacramento River. Saskatoon Municipal Railway Car No. 12, a privately owned streetcar held by BAERA, was the vehicle used for this occasion.

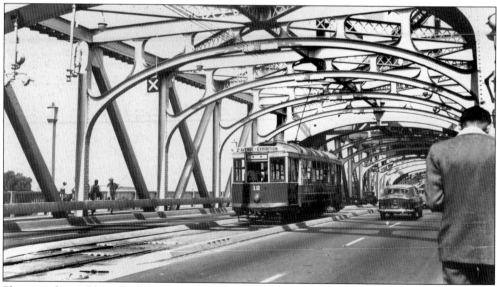

Photographer Addison Laflin captured Car No. 12 crossing the Tower Bridge via its single track. The rails running down the center of the Tower Bridge were removed in 2005. In addition to automobile traffic, the Tower Bridge carried railroad traffic until the 1960s. The electric overhead wire was removed in 1953, but the Sacramento Northern's diesel-electric locomotives carried freight via this bridge for another decade.

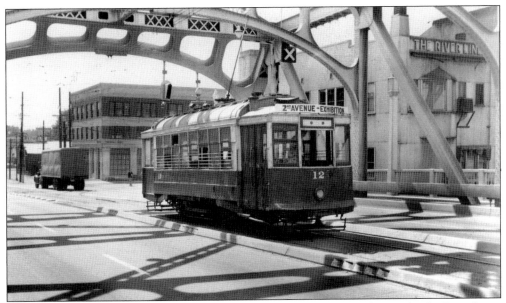

Roy Covert photographed Car No. 12 from the other direction. From this angle, the River Lines warehouse along Front Street is visible. Front Street included a large number of warehouses, processing and packing plants, and other industries when Sacramento's waterfront received large volumes of waterborne freight. The Port of Sacramento relocated most of this traffic.

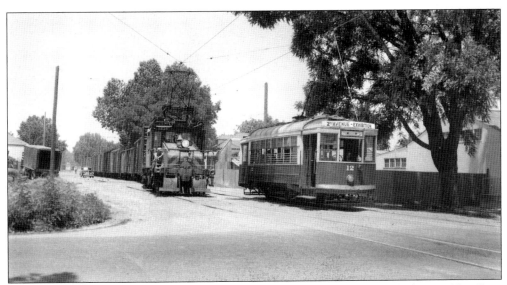

Sacramento Northern electric steeple cab 654 pulls a string of boxcars past Saskatoon No. 12 on Front Street. Locomotive No. 654, a General Electric product, is at the Western Railway Museum today and is currently the subject of a restoration project. After the wire came down in Sacramento, No. 654 worked at the Sacramento Northern's Marysville/Yuba City branch until 1965.

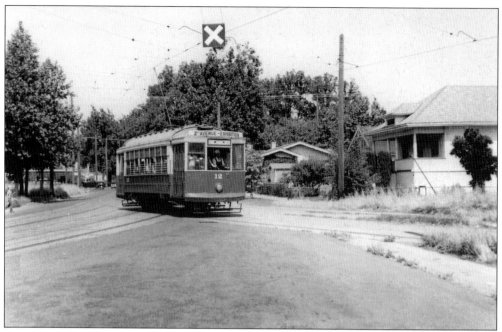

From Front Street, Car No. 12 turned onto X Street, which was used by Sacramento Northern and Central California Traction until 1966. Here the tracks diverge at X Street and Alhambra Boulevard. Rather than turning south towards Broadway where the CCT streetcar had run, Car No. 12 turns north up Alhambra Boulevard. CCT switched to diesel power in 1946, and the end of streetcar service eliminated the need for electric overhead south of X Street.

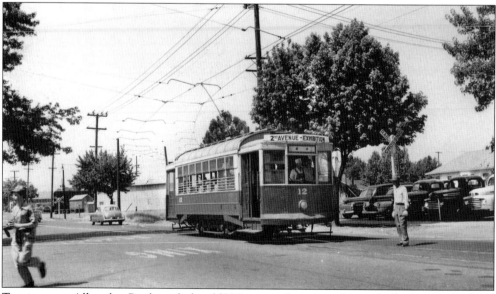

Turning onto Alhambra Boulevard, the old X Street carbarn is visible in the background behind Car No. 12. It was sold to a vegetable wholesaler after the end of streetcar service. Sacramento Northern's main line on Alhambra Boulevard continued north to Stockton Boulevard in order to serve the Libby, McNeil, and Libby cannery until 1966.

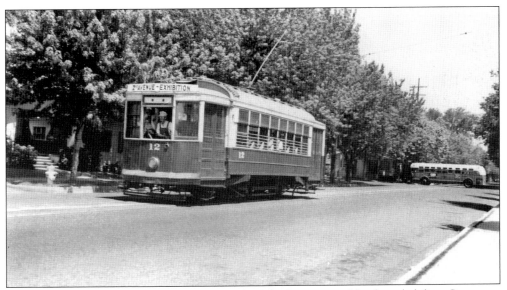

On Alhambra Boulevard, a bus crosses the path of the Sacramento Northern belt line. Streetcars did not operate between X Street and McKinley Park, but freight trains traveled all the way up Alhambra Boulevard until 1953. After that year, Sacramento Northern trains used the Western Pacific main line between X and C Streets.

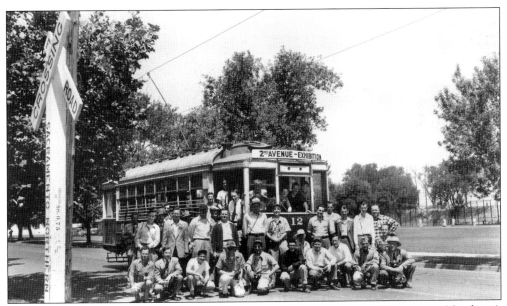

At the ballpark on Twenty-eighth and C Streets, on the former route of Sacramento Northern's Birney cars, the assembled BAERA rail fans temporarily leave the car for a group photograph captured by Stanley Snook. The Southern Pacific main line, on its elevated berm, is in the background behind the park.

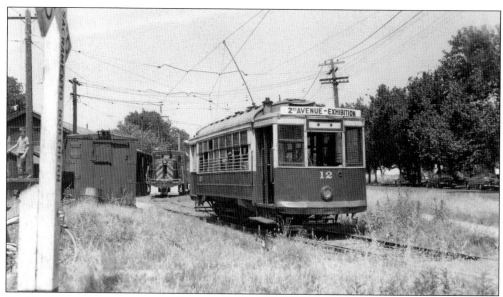

Car No. 12 stopped temporarily at the storage yard on Seventeenth and D Streets. This yard, where Elverta Scoots, interurban cars, and the SN Birneys had been stored, was used for locomotive storage until 1971. Behind the streetcar, Sacramento Northern No. 141, a 44-ton diesel-electric locomotive, sits in the yard.

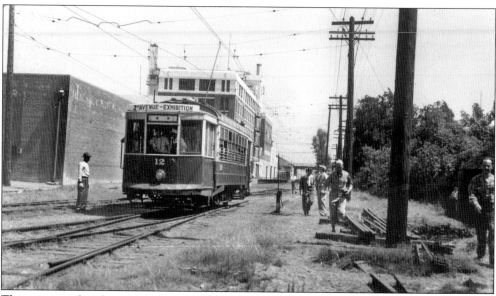

This private right-of-way on Eighteenth Street was used by Sacramento Northern freights but was also part of the Sacramento Northern streetcar route. The California Almond Growers Exchange dominates the background. It, along with Golden State Dairy and the California Packing Company plant on C Street, were still busy customers of Sacramento Northern's freight business.

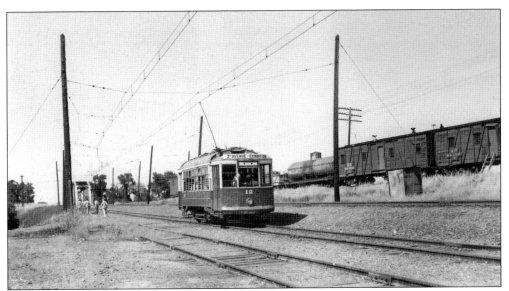

Car No. 12 is seen here in Haggin Yard, Sacramento Northern's classification and interchange yard. Freight cars are exchanged here between Sacramento Northern, Southern Pacific, and SN's parent company, Western Pacific. Sacramento Northern's railroad bridge across the American River is seen in the background; today it is a Rails-to-Trails pedestrian bridge.

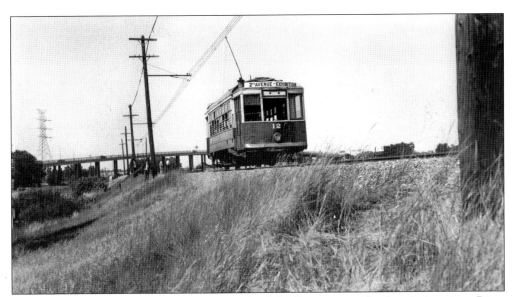

Car No. 12 reaches the end of the line, north of the Sacramento Northern's American River bridge. Overhead wire ends at this point. Prior to 1946, third-rail power continued from this point, but its use was banned due to safety risks. The SN's Birneys used third-rail shoes to travel north to Chico for maintenance, the only single-truck Birney cars ever to use third-rail power. Highway 160 is visible in the background.

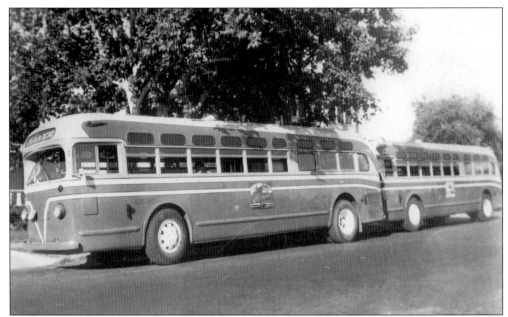

Sacramento City Lines replaced the streetcars and the older PG&E buses with GMC buses like these. The United States Justice Department eventually filed an antitrust lawsuit against SCL's parent company, National City Lines, and found that NCL companies purchased buses exclusively from General Motors, a primary shareholder, shutting out any competitors. In 1954, Sacramento founded Sacramento Transit Authority to operate the city bus system. (Bob Blymyer collection.)

While buses provided public transportation, Sacramento's streets, like those in most American cities, were ruled by the automobile. In this photograph, taken at Fifteenth and K Street in front of the Maydestone Apartments, automobile traffic dominates the street. Note that traffic on Fifteenth Street is one-way. A major reason why Sacramento wanted to discontinue streetcar service was to add one-way streets to increase traffic flow. (Author's collection.)

These are fare tokens from Sacramento streetcar and bus routes. The small tokens are full-fare tokens and the large ones are half-fare tokens, used by students and sometimes called "school fare" tokens. The one on the far left is a Sacramento Transit Authority token, the next two are from the Sacramento City Lines era, and the two on the right are PG&E tokens. (Author's collection.)

## WEEK DAY — ST. CAR SCHEDULE
### 3 — J Street

| Leave S. P. Depot | | | Leave 46th & J St. | | |
|---|---|---|---|---|---|
| 5:50 | 12:13 | 5:13 | 5:30 | 11:00 | 4:50 |
| 6:10 | 12:23 | 5:18 | 5:50 | 11:10 | 4:55 |
| 6:30 | 12:33 | 5:23 | 6:10 | 11:20 | 5:00 |
| 6:50 | 12:43 | 5:28 | 6:30 | 11:30 | 5:05 |
| 7:03 | 12:53 | 5:33 | 6:40 | 11:40 | 5:10 |
| 7:13 | 1:03 | 5:38 | 6:50 | 11:50 | 5:15 |
| 7:23 | 1:13 | 5:43 | 7:00 | 12:00 | 5:20 |
| 7:33 | 1:23 | 5:48 | 7:10 | 12:10 | 5:25 |
| 7:43 | 1:33 | 5:53 | 7:20 | 12:20 | 5:30 |
| 7:53 | 1:43 | 5:58 | 7:30 | 12:30 | 5:35 |
| 7:58 | 1:53 | 6:03 | 7:35 | 12:40 | 5:40 |
| 8:03 | 2:03 | 6:13 | 7:40 | 12.50 | 5:50 |
| 8:08 | 2:13 | 6:23 | 7:45 | 1:00 | 6:00 |
| 8:13 | 2:23 | 6:33 | 7:50 | 1:10 | 6:10 |
| 8:18 | 2:33 | 6:43 | 7:55 | 1:20 | 6:20 |
| 8:23 | 2:43 | 6:53 | 8:00 | 1:30 | 6:30 |
| 8:33 | 2:53 | 7:03 | 8:05 | 1:40 | 6:40 |
| 8:43 | 3:03 | 7:13 | 8:10 | 1:50 | 6:50 |
| 8:53 | 3:13 | 7:23 | 8:15 | 2:00 | 7:00 |
| 9:03 | 3:23 | 7:33 | 8:20 | 2:10 | 7:10 |
| 9:13 | 3:33 | 7:45 | 8:25 | 2:20 | 7:23 |
| 9:23 | 3:43 | 8:00 | 8:30 | 2:30 | 7:38 |
| 9:33 | 3:53 | 8:15 | 8:35 | 2:40 | 7:53 |
| 9:43 | 3:58 | 8:30 | 8:40 | 2:50 | 8:08 |
| 9:53 | 4:03 | 8:45 | 8:45 | 3:00 | 8:23 |
| 10:03 | 4:08 | 9:00 | 8:50 | 3:10 | 8:38 |
| 10:13 | 4:13 | 9:15 | 9:00 | 3:20 | 8:53 |
| 10:23 | 4:18 | 9:30 | 9:10 | 3:30 | 9:08 |
| 10:33 | 4:23 | 9:45 | 9:20 | 3:40 | 9:23 |
| 10:43 | 4:28 | 10:00 | 9:30 | 3:50 | 9:38 |
| 10:53 | 4:33 | 10:15 | 9:40 | 4:00 | 9:53 |
| 11:03 | 4:38 | 10:30 | 9:50 | 4:10 | 10:08 |
| 11:13 | 4:43 | 10:45 | 10:00 | 4:20 | 10:23 |
| 11:23 | 4:48 | 11:00 | 10:10 | 4:25 | 10:38 |
| 11:33 | 4:53 | 11:15 | 10:20 | 4:30 | 10:53 |
| 11:43 | 4:58 | 11:30 | 10:30 | 4:35 | 11:08 |
| 11:53 | 5:03 | 11:45 | 10:40 | 4:40 | 11:23 |
| 12:03 | 5:08 | 12:10 | 10:50 | 4:45 | 11:50 |

Light face type indicates AM time.
Dark face type indicates PM time.

See other side for Route and Sunday Schedule.
Effective Feb. 4, 1939.

## 6 — 21st STREET
## ST. CAR SCHEDULE

### Week Day

| LEAVE S.P. Depot | | | LEAVE 35th & 5th Ave. | | |
|---|---|---|---|---|---|
| 5:48 | 11:42 | 5:27 | 5:21 | 11:37 | 5:17 |
| 6:09 | 11:54 | 5:37 | 5:41 | 11:49 | 5:27 |
| 6:30 | 12:06 | 5:47 | 6:01 | 12:01 | 5:37 |
| 6:45 | 12:18 | 5:58 | 6:16 | 12:13 | 5:47 |
| 7:00 | 12:30 | 6:09 | 6:32 | 12:25 | 5:59 |
| 7:13 | 12:42 | 6:20 | 6:46 | 12:37 | 6:10 |
| 7:20 | 12:54 | 6:32 | 7:02 | 12:49 | 6:21 |
| 7:27 | 1:06 | 6:44 | 7:14 | 1:01 | |
| 7:37 | 1:18 | 6:55 | 7:27 | 1:13 | |
| 7:47 | 1:30 | | 7:37 | 1:25 | **BUS** |
| 7:57 | 1:42 | | 7:47 | 1:37 | |
| 8:06 | 1:54 | **BUS** | 7:57 | 1:49 | 6:32 |
| 8:17 | 2:06 | | 8:07 | 2:01 | 6:47 |
| 8:27 | 2:18 | 7:10 | 8:17 | 2:13 | 7:02 |
| 8:37 | 2:30 | 7:25 | 8:27 | 2:25 | 7:17 |
| 8:47 | 2:42 | 7:40 | 8:37 | 2:37 | 7:32 |
| 8:58 | 2:54 | 7:55 | 8:48 | 2:49 | 7:47 |
| 9:06 | 3:06 | 8:10 | 8:59 | 3:01 | 8:02 |
| 9:18 | 3:18 | 8:30 | 9:13 | 3:13 | 8:17 |
| 9:30 | 3:30 | 8:50 | 9:25 | 3:25 | 8:32 |
| 9:42 | 3:42 | 9:10 | 9:37 | 3:37 | 8:52 |
| 9:54 | 3:54 | 9:30 | 9:49 | 3:47 | 9:12 |
| 10:06 | 4:07 | 9:50 | 10:01 | 3:55 | 9:32 |
| 10:18 | 4:17 | 10:10 | 10:13 | 4:07 | 9:52 |
| 10:30 | 4:27 | 10:30 | 10:25 | 4:17 | 10:12 |
| 10:42 | 4:37 | 10:50 | 10:37 | 4:27 | 10:32 |
| 10:54 | 4:47 | 11:10 | 10:49 | 4:37 | 10:52 |
| 11:06 | 4:57 | 11:30 | 11:01 | 4:47 | 11:12 |
| 11:18 | 5:07 | 11:50 | 11:13 | 4:57 | 11:32 |
| 11:30 | 5:17 | 12:10 | 11:25 | 5:07 | 11:52 |

ROUTE—S. P. Depot to 3rd St. to K St. to 21st St. to 2nd Ave. to 24th St. to 5th Ave. to 35th St. and return.

Light face type indicates AM time.
Dark face type indicates PM time.

Effective May 4, 1941.

Streetcar schedules and other ephemera are often collected by rail fans. Schedules, brochures, route maps, and other paperwork associated with streetcars were commonplace items but were seldom kept because they were, by their nature, disposable. These car schedules show the frequency of car service in Sacramento—on J Street, a No. 3 car came by every five minutes during the workday and ran until just before midnight. (Author's collection.)

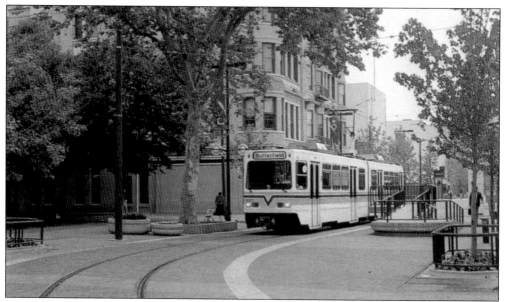

In 1987, Sacramento Regional Transit District inaugurated its new light-rail vehicles. The original light-rail line ran from Watt Avenue and Interstate 80, through downtown Sacramento at Seventh and K Streets (seen in photograph above), and turned west to end at Thirteenth Street. After September 1987, the line was extended to Butterfield Station, just east of Rancho Cordova. K Street again rang with the streetcar's bell and the ring of metal wheels.

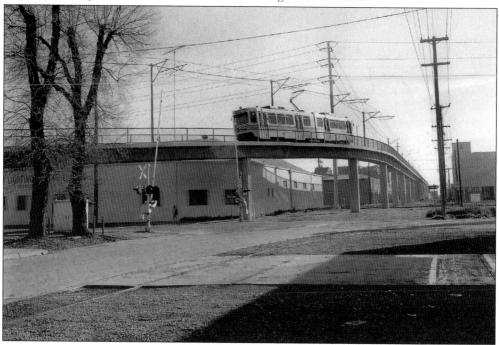

The line runs on K, Seventh, and Eighth Streets, a former PG&E right-of-way, but also on Whitney Avenue and on R Street. The Bee Bridge carries trains above busy Nineteenth and Twenty-first Streets. Trains today run all the way to Folsom, once served by Southern Pacific's McKeen cars, and the track in the foreground now carries the Regional Transit south line to Meadowview.

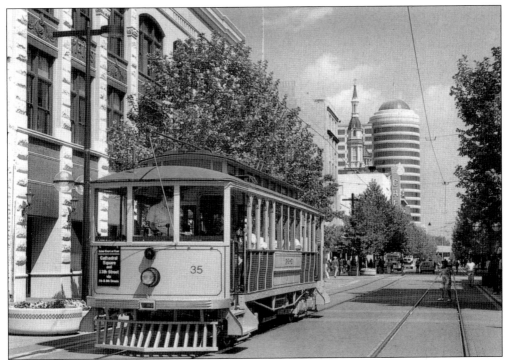

PG&E Car No. 35, one of Sacramento's 1914 American Car Company streetcars, was sold to San Jose and restored. It was purchased by Regional Transit in 1999 and is operated in downtown Sacramento on special occasions. Many transit advocates have suggested that Car No. 35, and other former Sacramento cars in storage but not yet restored, could be used as part of a historic streetcar line in Sacramento.

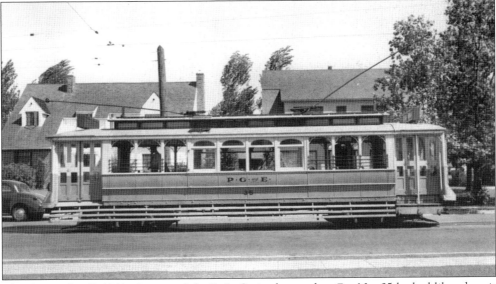

This September 7, 1941, photograph by R. L. Stein shows what Car No. 35 looked like when it belonged to PG&E. Although built as a California car, Car No. 35 was rebuilt as an enclosed car in the PG&E shops. It was restored to its original California car configuration after its transfer to San Jose.

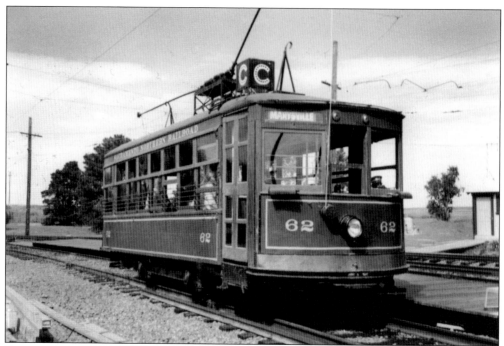

Sacramento Northern Birney No. 62 operates today at the Western Railway Museum. Some of the SN Birneys were used by SCL as trolley wire greasers, but only Car No. 62 has survived. It has been restored to its original appearance and carries passengers around the museum grounds. BAERA also holds three PG&E cars, Nos. 41, 46, and 63, in unrestored condition at the museum. (Author's collection.)

Substation A, which received long-distance electric transmission from Folsom Dam in 1895 and provided power for Sacramento's streetcars for over half a century, still stands at Sixth and H Streets in downtown Sacramento. The grounds behind this building still contain a working electrical substation today. (Author's collection.)

# BIBLIOGRAPHY

Anderson, Christy and William E. Mahan, "History of McKinley Park." *Sacramento History Journal*, Vol. III, No. 1. Winter and Spring 2003.

Bottles, Scott L. *Los Angeles And The Automobile: The Making of the Modern City*. Berkeley, CA: University of California Press Ltd., 1987.

Day, Rowena Wise, "Carnival of Lights." *Golden Notes*, Vol. 16. July 1970: 2–3.

Groff, Garth. "Sacramento Northern On-Line." Available at http://www.people.virginia.edu/%7Eggg9y/home.html.

Lucy, Eldon W. "The Mystery Trip." *The Circuit Breaker: An Occasional Publication of the Bay Are Electric Railroad Association*, Vol. 1, No. 38. June 3, 1951.

Mankoff, Al. *Sacramento's Shining Rails: A History of Trolley Transportation in California's Capital*. Canton, OH: Railhead Publications, 1993.

Railway and Locomotive Historical Society, Pacific Coast Chapter. "Street Railways of Sacramento." *The Western Railroader* No. 204. October 1956.

Railway and Locomotive Historical Society, Pacific Coast Chapter. "Street Railways of Sacramento," *The Western Railroader*, No. 530. May 1987.

Reed, G. Walter, *History of Sacramento County*, Los Angeles: Historic Record Company, 1923.

*Sacramento County and its resources: A Souvenir of the Bee, 1894*. Sacramento, CA: H. S. Crocker Company, 1895.

Stanley, David G. and Jeffrey J. Moreau, *Central California Traction: California's Last Interurban*. Wilton, CA: Signature Press, 2002.

Swett, Ira L. *Sacramento Northern: Interurbans Special 26*. Glendale, CA: Interurban Press, 1962.

Swett, Ira L. *Cars of Sacramento Northern: Interurbans Special 32*. South Gate, CA: Interurban Press, 1963

Smallwood, Charles A. "The PG&E Sacramento City Car Lines," *The Street Railway Review*, No. 16 and No. 17. 6–10 and 13–18.

Wright, George F., ed., *History of Sacramento County, California*, Oakland, CA: Thompson and West, 1880.

# ACROSS AMERICA, PEOPLE ARE DISCOVERING SOMETHING WONDERFUL. THEIR HERITAGE.

Arcadia Publishing is the leading local history publisher in the United States. With more than 3,000 titles in print and hundreds of new titles released every year, Arcadia has extensive specialized experience chronicling the history of communities and celebrating America's hidden stories, bringing to life the people, places, and events from the past. To discover the history of other communities across the nation, please visit:

# www.arcadiapublishing.com

Customized search tools allow you to find regional history books about the town where you grew up, the cities where your friends and family live, the town where your parents met, or even that retirement spot you've been dreaming about.